JAPANESE COLOUR PRINTS

J. Hillier

Phaidon Press Limited
Regent's Wharf, All Saints Street, London N1 9PA

Phaidon Press Inc.
180 Varick Street, New York, NY 10014

www.phaidon.com

First published 1966
Second edition 1971
Third edition 1972
Fourth edition, revised and enlarged, 1981
Fifth edition 1991
© 1966, 1971, 1972, 1981, 1991 Phaidon Press Limited

ISBN 0 7148 2721 5

A CIP catalogue record for this book is available from the British Library

Printed in Singapore

The publishers wish to thank all private owners, museums, galleries and
other institutions for permission to reproduce works in their collections.

Cover illustrations:
(front) Utagawa Kunisada: *The Actor Ichikawa Danjuro in Character*,
c.1820 (Plate 48)
(back) Katsushika Hokusai: *Fuji in Clear Weather*, c.1823-9 (Plate 43)

JAPANESE COLOUR PRINTS

Japanese Colour Prints

The Pictorial Art of Japan

The colour-print was in the main, though not exclusively, the product of a certain school of painters that arose in the seventeenth century, whose methods were considered sufficiently different from those of the established schools to earn a name of its own, the *Ukiyo-e*, or 'Pictures of the Floating World' School. But although that title, with its hint of opprobrium, suggesting as it does a concern with the petty things of everyday life in contrast to the 'eternal verities' that engaged followers of older schools, distinguishes a quite clearly separate style of Japanese painting, that style is still essentially Japanese, and an explanation of certain of the characteristics of the colour print best begins in a general consideration of the art of painting as practised in Japan. A comparison, at the same time, with Western art, gives an opportunity to deal with some of the objections to Japanese art which are almost inevitably raised by those steeped in the Western traditions who approach it for the first time. Perhaps 'comparison' is hardly an accurate term where such incompatibles are concerned, for though identical in that both are pictorial means of expression, the gulf between them is deeper than the Pacific.

Japanese painting is more limited in range than European: but more perfect within its prescribed limits. Its limitations were due in part to the restricted media and opportunities open to the Japanese compared with those available to the Western artists, to whom the advent of oil-painting gave possibilities of expression never accepted by the Japanese, or, as some would say, wisely eschewed by them. It is true that modern Japanese artists have used oils, but in doing so they have adopted European methods, and in any consideration of the art of their country one refers to the products of the purely native schools, Kano, Tosa, Korin, Shijo – a Japanese, painting in a Western style, loses his national identity as completely as his countryman who forsakes the *kimono* for the lounge suit.

Oddly enough, the choice of media was imposed on the Japanese as much by geological and climatic factors as by any innate artistic preference or instinct: the flimsy construction of their buildings, dictated by the recurrence of earthquakes and leading to frequent conflagrations, precluded anything like the great wall spaces enjoyed by the early European painters in fresco and tempera, or even the solid frame and robust canvas normal to our oil painters. Instead, they used water-colours on silk and paper, materials which, in the characteristic *makimono* and *kakemono* forms (the first a long horizontal, the other a tall vertical, oblong), could be rolled up and moved to a place of safety, where for the most part of the year they were stored.

The use of water-colour, and later of woodcuts printed in colours, tended to stand in the way, if there had been any movement in that direction, of any laborious technique which might have led, as the oil-painting technique did in Europe, to the mimicry of visual appearances. But water-colour *could* have been turned to this copy-work – after all, Birket Foster used identical materials; but from the first, the Japanese genius was for the expressive line, for pattern and design, the representation of natural objects as a means to an end, not an end in itself. Chiaroscuro and linear perspective, used by Western artists to give the verisimilitude of solidity in natural objects and their recession in space, were ignored, though not unknown. Normally they did not 'draw from nature' as we are, or were, taught to, but stored images in the mind until the mood was upon them to paint: with them, painting, like poetry, was the 'spontaneous overflow of powerful feelings' and took its origin from 'emotion recollected in tranquillity'.

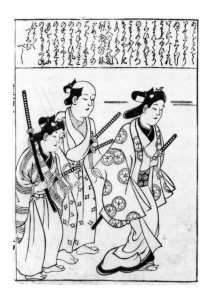

Fig. 1
Hishikawa Moronobu:
Two *Samurai* and an
Attendant
From the book 'Pictures
of Rocks and Trees', 1683.
25.4 x 18.4 cm.
Private Collection

Fundamentally, the difference between Japanese and Western art lies not so much in media or technique as in the aim of the artists, the conception of the function of painting. With us, until comparatively modern times, the art of painting was tied to some underlying purpose of decoration, story-telling, portrayal of people or chronicling of events. Progress was measured by the closer and still closer approximation to the appearances of things, Ruskin typifying that form of art criticism that uses 'truth to nature' as the yardstick to measure a painter's stature. True, since Ruskin and the invention of photography, there has been a growing realization that the art of painting should reside in something more than the simple aim of imitation (contact with the art of the East from the nineteenth century onwards almost certainly speeded that realization); but until then, European painting was descriptive or objective, often the dependant of the sister art of architecture, often fulfilling the function that a camera fulfils today. The paintings of El Greco and William Blake, to name two at least who are exceptions to the rule, have qualities that failed to find general acceptance.

The work of the Japanese painter, unhampered by the external considerations that pressed upon the European, was valued for the 'beauty and significance of touch', the actual brushstrokes, the arabesque of their line, having, for people who appraised calligraphy as one of the fine arts, an appeal that we learn but slowly to appreciate; and conveyed, to the well-stocked mind, not directly but by hints and allusions, a whole world of meaning lost upon us. There is nothing in their art akin to the portraiture of Reynolds, still less of Rembrandt or Velazquez; no landscapes of the fidelity to topography and atmosphere that Constable, Turner or Monet achieved; little of the allegorical, narrative or didactic painting, the 'sermons in paint' which, on wall and canvas, from Giotto to Brangwyn, have been accepted as one of the functions of the art in the West. Theirs was an art in which line and hue and *notan* were evocative in the way that a word, or a turn of phrase, is evocative in our poetry. Laurence Binyon, referring to the classic Kano school, wrote: 'The one thing necessary for a work of art was that it should bring with it the fertilising seed to come to flower in the beholder's mind: the thought of the artist was to enter like a guest into a room made ready for his welcome.'

The Origin of the Colour-Print

It can readily be imagined that even among the Japanese such an art could only be addressed to those of a culture comparable to that of the artists, and in fact its appreciation was restricted to the aristocratic minority of the nation. The art of Ukiyo-e, of the colour-print artists, was, on the other hand, the art of a popular school, and for that reason if for no other, the colour-prints are more readily enjoyed by us than the works of the earlier masters: indeed, though their allegiance is decidedly to the East, they seem to occupy a sort of border state between East and West, with an artistic climate more nearly approaching our own, and whence we can approach by an easy gradient to the more difficult peaks, the rarefied atmosphere of the ancient classical art.

The advent of such a popular art was bound up with great social changes, and was dependent on the emergence of a class of people that had no previous counterpart. After generations of internecine struggles, the firm rule of the Tokugawa Shogunate, first installed to power at the beginning of the seventeenth century, brought stability and prosperity to the troubled country, and the population of the new capital, Edo, grew rapidly. Education was more widely disseminated

than ever before, and a middle class of tradesmen, artisans and merchants emerged, quick-witted, intelligent, pleasure-loving and avid for novelty. It was for this parvenu class that the *Kabuki*, or Popular Drama, the Marionette Theatre, and an immensely varied and voluminous literature came into being, and it was to illustrate the publications of the day that the first Ukiyo-e woodcuts were made. Before considering the gradual development of the colour-print from these first beginnings, it is well to go a little deeper into a question of paramount importance in Japanese art – Style.

The Ukiyo-e Style

Consistent with the acceptance of painting as an art in its own right, styles of painting in Japan are differentiated more on the grounds of brushwork than on the type of subject-matter. The Ukiyo-e style is primarily a style of *painting,* which emerged with a clearly separate identity in the seventeenth century, but whose origins were complex and traceable to a number of different artists of the late sixteenth and early seventeenth centuries, all of whom showed an unusual interest in the passing scene, in the fashionable clothes and vices, and who were seeking, tentatively at that stage, a pictorial language adequate to convey their worldly outlook. These early artists expressed themselves in paintings only – the Ukiyo-e woodcut did not arrive until the second half of the seventeenth century. In the make-up of their style are elements borrowed from both the Tosa and the Kano schools, the vivid opaque colour of the one, the strong forceful bounding line of the other, and moreover, the class of subject depicted, something approaching a Japanese genre, had only occasionally appeared before, especially in the Yamato-e scrolls, the narrative paintings of the first truly native artists, active from the tenth to the thirteenth centuries.

But the paintings, executed for comparatively wealthy patrons, were limited in number and in circulation. The style was first directed to a wider audience by some anonymous book-illustrators of the mid-seventeenth century, and soon after Moronobu, in prolific illustrations to books and later in separately issued broadsheets, imposed a style in drawing for the woodcut and a range of subject-matter that proved the greatest single influence on the subsequent history of the colour-print.

In a selection of prints such as those reproduced here, one of the most striking features is the oneness of the style that, for all the developments in technique and the following of changing fashions in dress and manners, informs the work of artists of widely separated periods. The exceptions are to be found in the essays in the Kano or Chinese styles that occasionally occur; in the flirting with European methods in such prints as the 'perspective pictures' known as *Uki-e;* and in some phases of the work of Hokusai, whose eclecticism, his assimilation of the styles of a variety of schools, renders some of his prints barely classifiable as Ukiyo-e, notwithstanding the colour-print medium.

Without a comparison, not possible here, with the other various styles of Japanese painting, it is rather difficult to bring home the characteristics that single out a Ukiyo-e drawing from that in any other style: but suffice to say that there is an immediately obvious kinship, notwithstanding the differences already noted, between the drawings of a woman by such diversely gifted artists as Moronobu, Kaigetsudo, Okumura Masanobu, Harunobu or Kiyonaga, and an equally clear distinction between their drawings and those of a Kano or Tosa master. Although the Ukiyo-e style was based on both the Kano and the Tosa, its suave flowing lines are never mistakable for

the impetuous, splintery strokes of the Kano masters, and the lively near-naturalism of its figure-painting is a world apart from the stiff, ritualistic manner of the Tosa.

This continuity of a style through generation after generation of artists was the result of the method of training. A pupil accepted by one of the masters was like the apprentice to any other craftsman: he followed implicitly the instructions of the master, reproduced his productions as closely as possible. We in the West, at any rate since mediaeval times, have no parallel to the rule and authority exercised by the Japanese painter over his pupil: not only had the main tenets of the school of adoption to be respected, but the particular idiosyncrasies of the sub-school in which the young artist had enrolled had to be followed with complete fidelity. Hence the great similarity – the impossibility of telling apart, quite often – of the prints, say, of Harunobu and his pupils (one named Harushige openly confessed to forging Harunobu's signature, and no two experts have ever agreed as to which are the forgeries); of Shunsho and those of his pupils who produced theatrical prints; of Kiyonaga and all those that fell under his sway, such as Shuncho and Eishi.

Without knowing the prints, it might be inferred that such a system could only lead to servile copying and stagnation, but, in fact, the reverse was the case. Each great artist, and there was a constant succession of them, beginning as an imitator of his master, developed an individuality in drawing and treatment of subject that stamp his prints as plainly as the signature or seal upon them: and that he, in his turn, was successfully imitated by his successors only emphasizes his distinctive achievement as an innovator.

In perhaps no other aspect can this be made clearer than in the drawing of women, to whom, above all, the Ukiyo-e artists devoted their work. The small, compactly-drawn figures of Moronobu (Plate 1) are given imposing build and monumental poise in the massive lines of Kaigetsudo (Fig. 2) and Kiyonobu; Okumura Masanobu and Sukenobu infuse a new sweetness, a graciousness of mien and movement absent before; Harunobu reduces them to captivating child-women, of flower-like fragility, but Koryusai, Shigemasa and Kitao Masanobu gradually, with an increase in naturalism, give the figures nobler lines again, culminating in the queenly, Junoesque forms that Kiyonaga drew; while with Eishi, Choki and Utamaro, yet new, disturbing characteristics appear, the allure of languor and sophistication. The power to rise above the stereotyping that this system of tutelage tended to enforce is the mark of the great artist.

A criticism often levelled at the Japanese print, or at Japanese painting generally for that matter, is that there is no characterization in the features, that all the faces look alike. Superficially, there is some truth in this; and the cause brings me back to my starting point, the distinction between Oriental and Occidental art. There was no *prima facie* obligation in the Japanese conception of painting to reproduce visual appearances: natural forms, of which the human head is one, were introduced into a picture with only as much realism as was compatible with the painter's objective: and so the face, as an element in the design, received no more, and no less, attention than the other components in that design. Singling out the face for detailed treatment would have unbalanced the composition: in fact, their art, relying primarily on line without the Western device of chiaroscuro, tended to become caricatural when portraiture was attempted, as Sharaku's prints, with their greater realism, tend to prove.

But within these limits, there are evident differences between each great artist's depiction of the head: each had his own ideal, his work can be identified by his predilection for a certain facial type, as a study of the reproductions will show. For instance, however close in other respects the drawings of Harunobu, Buncho and Shunsho may

have been at one period, there is no mistaking the small-featured demure face of Harunobu's *musume* for the aquiline, more experienced face of Buncho's, or the rounder, placid countenance favoured by Shuncho for either. Utamaro went even further, and proclaimed himself on a certain famous series of prints the 'Physiognomist', and although even these heads are far from satisfying our own ideas of portraiture, there is evident characterization of recognizable types: types, be it noted, rather than individuals: the general rather than the particular.

The Technique of the Colour-Print

The success of the illustrated book, and the demand by the common people for pictures that could be displayed, as in the upper-class houses, in the *tokonoma*, a quiet corner of a room where a picture could be contemplated with undisturbed serenity, led to the production of separate broadsheets, *ichimai-e*, of larger size than the normal illustrated book. These broadsheets were at first in black outline only, but within a very short time the need to imitate paintings more closely led to the application of colour by hand, and so the earliest Japanese print – not a true 'colour-print' at this stage – is in outline only, or roughly touched in with strong colours that match the forceful lines of the woodcut.

There is nothing more impressive in the whole range of Japanese art than the large prints of the great masters of this period, Moronobu, Kaigetsudo, Sugimura (Fig. 3), the first Kiyonobu, Kiyomasu and the young Okumura Masanobu. In their depictions of courtesan and paramour, actor and theatre-goer, there is the swing of an undulating line, a rhythmic flow in design and a boldness of contour admirably fitted to the woodcut line.

An additional refinement introduced during this period was the application of lustrous black and of brass and other metal dusts over a gum base in imitation of lacquer-work with applied gold. Known from this as 'lacquer-prints', *urushi-e*, this kind of print is often of a barbaric splendour in its sombre colour and glinting brass-dust, and some supremely beautiful examples were designed by Kiyomasu, Okumura Masanobu, his pupil Toshinobu, and Shigenaga.

The outline and hand-coloured prints prevailed for several decades, and it was not until about 1740 that colours as well as the outlines were printed from wood-blocks, and even then, for another twenty years or so, the colours so applied were limited to two, usually a light red and a green. With the coming of the two-colour prints came a change in the designs, a tendency to smaller size, to slendered figures, less robust decorative motifs: a change due, it seems likely, to the artists' unerring sense of balance, the feeling that the rose and green would be garish if applied to prints on the scale of the outline-prints that had hitherto prevailed.

Okumura Masanobu, one of the greatest of the 'primitives' and responsible for a number of innovations, is again one of the outstanding figures where the two-coloured prints *(benizuri-e)* are concerned, but by this time numerous artists of merit were working in the Ukiyo-e style, notably the second Kiyonobu; Kiyohiro, and Kiyomitsu Shigenaga and Toyonobu (Fig. 5). With these artists one notices a gradual introduction of fresh motifs for the broadsheets, idyllic scenes in which exquisitely clothed figures move gracefully against a lightly-indicated background, the curve of a river, the cone of Fuji beyond the ricefields, the corner of a tea-house with a bamboo beside it.

This idyllic, consciously poetic element became all-pervading in the work of Ukiyo-e artists, and was miraculously enhanced by the introduction in 1764/5, traditionally by Harunobu, of the full poly-

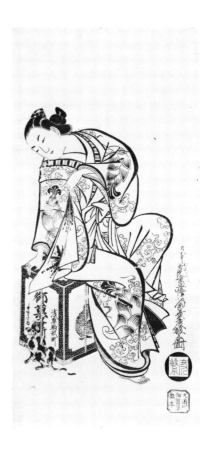

Fig. 2
Kaigetsudo Dohan:
Seated Courtesan
Teasing a Cat
Sumizuri-e. 64.5 x 31.1 cm.
Private Collection

9

chrome print, the true *nishiki-e*, or brocade-print, as it was called. The accession of new technical resources, the incentive given by a public gradually more cultured and discerning, brought an immense response from the artists, and from Harunobu onwards (his great output in full colour was limited to the six years between 1764 and his death in 1770), there was a succession of artists of first rank: Koryusai (Figs. 4 and 6); Shigemasa and his pupils Kitao Masanobu and Masayoshi; Shunsho and his pupils Shunko and Shunei; Toyoharu; Kiyonaga and his followers, Shuncho, Shunzan and Shunman; Eishi and his pupils Eisho, Eisui and Eiri; Utamaro; Choki; Sharaku; Hokusai and his pupils Hokkei and Gakutei; Toyohiro; Toyokuni and his pupils Kunimasa, Kuniyoshi and Kunisada: Hiroshige; Eisen. This makes a formidable list of names, but some conception of the wealth of talent exerting itself in the field of the colour-print is obtained if it is realized that even this long list could be doubled by including names of other pupils and independent artists whose work, if rarer, is often of very high quality.

The colour-print was the result of the collaboration of four distinct people: the publisher, who commissioned the work and co-ordinated the operations of the other three concerned in its production, and whose importance, consequently, cannot be over-rated – many of the finest prints are due to the enterprise and discernment of publishers like Tsutaya Jusaburo and Eijudo; the designer, with whom this book is most intimately concerned; the engraver; and the printer. To these, some would add a fifth, quite logically – the paper-maker: the superb texture and surface of the hand-made, mulberry-bark papers do much to enhance the bloom and soft radiance of the colours.

The woodcut medium came naturally to the Ukiyo-e artists. There was already in existence a body of facsimile wood-engravers, long trained in the cutting of brush-drawn characters for the texts of books. To such engravers, the cutting of an outline block from a brush drawing supplied by the artist was a comparatively simple matter, and an extremely high standard of fidelity was normal. It is a matter of surprise that the application of colour by wood-blocks was so long deferred, for Chinese colour-prints of the seventeenth century, employing a wide range of colours, must have been known in Edo. No doubt the need to keep the price within the reach of the humble Edo folk was one of the factors responsible.

A great deal depended on the craftsmen responsible for block-cutting and printing. The artist merely supplied the drawing on transparent paper and indicated the colours by painting them in on a 'pull' from the 'key-block', as the outline print was known. The engraver, pasting the drawing face-down on a block of hard wood like cherry (not on the 'end-grain' as has been customary in the West since Bewick's day, but on the 'plank' in the manner of Dürer's engravers), cut around the lines with a knife, and by clearing the wood between the lines, left them in high relief. The ink having been rubbed on to the raised lines, proofing paper was placed over the block, pressure was applied by rubbing a twist of hemp over the back of the paper, and a proof of the engraver's facsimile of the artist's design thus secured.

Usually, the artist's original drawing was cut to pieces by the engraver in preparing the key-block, but a number of brush drawings for prints exist which seem to suggest that in some cases the engraving was made from a copy of the original design.

After the artist had indicated the colours on a proof of the key-block, a separate block had to be cut for each colour that was to be printed, and in a print of complex tints, as many as ten or more such additional blocks might be required, from which, with over-printings, a remarkable range of colour was obtainable. The colours were mixed by the printer on each block separately, a little size made from rice

being added to give a firm consistency. Accuracy or register, of first importance as a print passed from one block to another to receive its succession of colours, was secured by a guide mark for the proofer, consisting of a right-angle cut at one corner of each block and a straight line at an adjoining side, aligned with one side of the right-angle.

Until the nineteenth century, the colours were mainly of vegetable origin, and, unfortunately, fugitive on exposure to light, the sky-blue, violet and pink fading to buffs and greys still beautiful in themselves, but something quite different from the bright hues that originally caught the eye of the Edo purchaser. With the singular perversity of their race, some collectors have affected to admire the time-faded print in preference to another in its original colours, but although many fade in harmony, the quiet, subdued tones of such prints are those of preserved flowers, lacking the gaiety and liveliness of the living thing. Besides, quite often the precious harmony of colour achieved by some artists, Harunobu in particular, is destroyed when more stable greens, yellows and a chocolate brown remain unimpaired whilst other shades have become uniformly dulled. To collectors of the kind mentioned, the print in its original state comes as much of a shock as cleaned pictures, seen at last in all their bright colour, come to lovers of the 'embrowned' tones of the Old Masters.

Among the various embellishing devices used by the printer are the use of mica in backgrounds, or for picking out mirrors and frosty or icy surfaces; the application of metal-dusts, either sprinkled or applied by block; and *gauffrage*, or blind printing, for indicating the patterns and folds of dresses, the plumage of birds or the fur of animals, by lines in relief but without colour.

There seems to be no certainty as to the number of prints taken from one set of blocks, but an extant letter of Hokusai's to one of his publishers set the limit at 200 prints. After long use, a saturated block ceases to take colour evenly and the fine lines begin to wear down, but modern block-makers concerned with producing facsimiles of old prints, take many more proofs than 200 from a block, and one publisher has expressed the view that a thousand or more can be taken before the block deteriorates.

From a variety of causes, the sizes and shapes of the prints were constantly changing, but only the formats peculiar to the Japanese print need be mentioned. As a substitute for paintings, it was natural that quite early the *kakemono-e* should have been introduced, since this most nearly resembled the hanging painting, and it was, in fact, often mounted like a painting on rollers. The diptych, triptych and other multi-sheet prints seem to have had their origin in the practice, prevalent among painters of the established schools, of producing two or three separate paintings that were linked partly by similarity of subject, partly by some underlying abstract theme, its roots, perhaps, in the teaching of the Zen sect of Buddhism, and beyond the reach of the unaided eye. But the colour-print triptychs, beginning in the Primitive period as three related figures printed adjacent to one another on a single sheet of paper (and usually cut into three by the owner), led to the diptych and triptych of Kiyonaga's time onward, in which the whole design was carried over two or three sheets which were intended to be joined at their edges, though, by a remarkable feat of designing, each sheet can be enjoyed as an independent entity, with no disturbing sensation that companion sheets are lacking to complete the picture.

Though uncommon, prints were produced comprising five sheets or more, and these more nearly correspond to the *makimono* or laterally-rolled painting. It was more often intended, I think, that these panoramic prints should be viewed, not as a single composition but piecemeal, a few sheets at a time, just as the old *makimono* was

Fig. 4
Isoda Koryusai:: The Party
From 'Twelve Bouts of
Passionate Love'. *oban*,
24.1 x 37.5 cm. Private
Collection

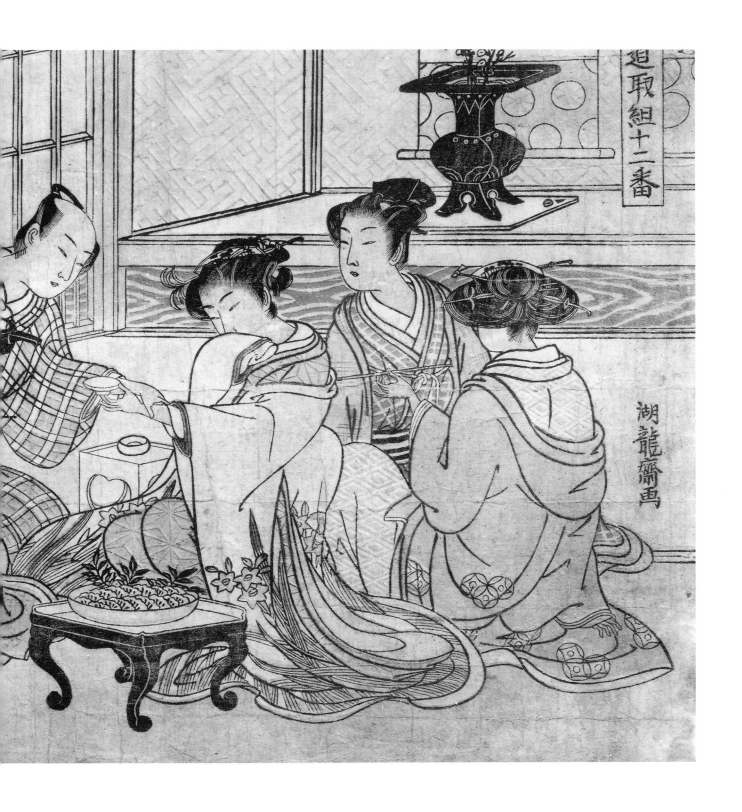

追取組十二番

湖龍齋画

Fig. 5
Torii Kiyomitsu:
Actors as Lovers in a
Play
1765. 43.8 x 30.8 cm.

unrolled to reveal only as much as the eye could take in at a glance.

Surimono (literally 'printed things') were prints issued for some specific occasion, as New Year's greetings, to celebrate a birth or a marriage, to commemorate a new membership to a poetry club, or to give notice of an author's or artist's change of name, no rare event; or were simply a vehicle for publishing the verses of the members of poetry clubs. They are usually of small size and characterized by the extreme delicacy of the printing, the lavish use of metal-dusts and *gauffrage,* and the welding of design and poetry into a decorative whole. Shunman, Hokusai and his pupils Hokkei, Shinsai and Gakutei excelled in these miniature works of art, which sometimes seem to trespass into the realm of the lacquerer.

The *hashirakake,* 'pillar-hanging' print, is, of all the formats used by the designers, the most essentially Japanese, and without a counterpart in Western art. Intended as a decoration for the wooden pillars that were a feature of the lightly-constructed houses of the country, the difficulties of designing within the tall, narrow limits of the panel seem to have challenged the Ukiyo-e artists to some of their finest achievements, comparable to the way that the limitation to seventeen syllables, all that the favourite form of lyric permitted, inspired the poets to remarkable feats of expressive compression. Harunobu, and especially Koryusai (Fig. 6), are the great masters of the *hashirakake* (or *hashira-e*), but Kiyonaga, Shuncho, Utamaro, Toyohiro and most of the outstanding artists of the latter end of the eighteenth century produced fine prints of this kind.

The Print-Sellers' Public

The colour-print's appeal to us is only in part due to the actual style of the Ukiyo-e school: it resides as much in the portrayal of a world utterly remote from our own, with dress, behaviour and custom intensely national, or influenced only from a quarter equally remote from us, China. It is this fusion of alien subject and individual style that makes the colour-print far more a national art, a 'folk' art if you will, than, say, Italian painting, however distinctive the latter may seem in relation to other European styles.

The formation of the new social class has already been touched upon as being the genesis of the colour-print. The character of the people of this plebeian class, their customs and daily life, their culture, have an intimate bearing on the nature of the prints.

Geographically, the Japanese are an isolated race. This insularity was accentuated in 1638, at a time when the Tokugawa regime was fully established, by laws proscribing intercourse with countries outside Japan; a policy that had its strength in that it preserved the country from distracting foreign influences, in the way of modern totalitarianism; and its weaknesses, that came from denying the people the broadening influence of other ways of life, other philosophies than their own, and of the benefits, albeit sometimes doubtful, of scientific progress being made elsewhere. But in respect of their art, the effect of the seclusion was wholly good, if one is to judge by the Europeanization that, after the revolution of 1868, ensued with results completely disastrous to the national genius.

But just as in-breeding leads to certain perversions and degenerate types, so in the Japan of this period there is something febrile and unbalanced: it is a world of rigid etiquette and extreme fastidiousness in dress, where, quite apart from the drama, men are often posed in feminine attire; and yet a world of the utmost grossness and brutality, where self-immolation is decreed for a peccadillo, and any crime sanctioned in the cause of revenge.

Too great a stress has often been placed, I think, on the low sta-

Fig. 6
Isoda Koryusai:
Feeding Carp
c.1771. 24.8 x 19 cm.

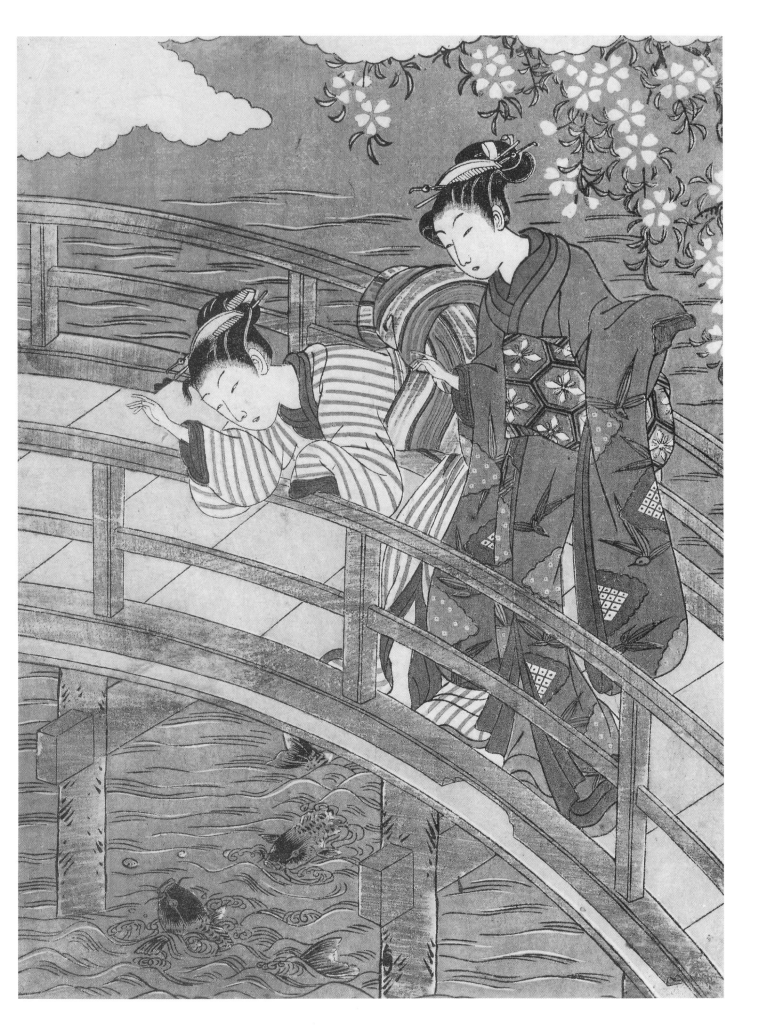

tion and vulgar taste of the people to whom the prints were purveyed. From the very nature of many of the prints, the refinement of the sentiment expressed, the artist's evident familiarity with classic poetry, it is obvious that they were acquired by people whose tastes were anything but coarse. There is a likeness here – it has been remarked before – between the people of Elizabethan England and the Japanese of the the Edo period; we are constantly surprised at the richness of allusion in Shakespeare, which modern editors need copious commentaries to explain, but which was a matter of everyday knowledge to the frequenters of the 'Globe'.

The eighteenth century saw, in fact, not only the increase in the literacy of those of lowest station, but also an intermingling of the military and controlling class with the wealthier merchants, considered very low in the social scale, and intermarriage between such disparates, unthinkable earlier, also helped to break down the former rigid barriers. It is well known that the *Kabuki* theatre, though considered an amusement for the lower classes, was, even if only clandestinely, frequented by the two-sworded men, the *samurai*, and we may be sure that many of the prints, and the finest of the illustrated books, were intended for the same exalted class. In a book of Hokusai's, 'The Pleasures of Edo', 1802, there is a picture of the print-shop of Tsutaya Jusaburo, one of the leading publishers of the day, with a *samurai* standing at the counter and showing a marked interest in the colour-prints, and a picture of a *samurai* seated in another publisher's shop, engrossed in one of the Ukiyo-e picture books, appears in a book of 1801 illustrated by Toyokuni. The work of Harunobu, Eishi, Utamaro, and Shunman, to cite only four, is often of that hyper-refinement termed by the Japanese *shibui*, and would assuredly have been lost on the vulgar herd.

But that there were extremes in the vast populace of Edo is not to be doubted, and the literature of the time, which, like the arts of the lacquerer and the potter, the silk-weaver and the painter, received new impetus and created new forms in the dynamic atmosphere of the period, ranges from moral and religious treatises of the *Kangakusha*, the enthusiasts for all things Chinese, to *kibyoshi*, 'yellow-backs' and fiction of various kinds, often of a pornographic type. Of this literature, by which some judgement of the taste and mental calibre of the people can be made, W. G. Aston wrote, 'But while the new literature is much richer and of a more vigorous growth than the old, there is a sad falling off in the point of form . . . Extravagance, false sentiment, defiance of probability, whether physical or moral, pedantry, pornography, puns and meretricious ornaments of style, intolerable platitudes, impossible adventures and weary wastes of useless detail meet us everywhere.'

As might be expected, the Ukiyo-e artists, as regards the subject-matter of their prints, can often be taxed with similar faults, but generally, certainly until the decline of the art in the nineteenth century, the age-old traditions of draughtsmanship and design still exerted a powerful influence, not lessened by affiliation to the new school. As an instance, one might take the books of erotic pictures. Practically every artist was responsible for books of this nature, books which were half-heartedly banned from time to time, but usually only slightly frowned upon by the authorities: but even in these the artists never forsook their high principles of drawing and composition, and, in fact, artists like Eishi and Utamaro seemed to find fresh access of powers in grappling with the problems set by imbroglios of nude and semi-nude figures, and some of their finest designs, reproduced by the most sumptuous colour-printing, are to be found in these *shunga*, 'Spring-drawings', as the erotic pictures are called.

Judged by their literature, and by the majority of the prints and picture-books, the commoners and their more aristocratic congeners

were obsessed with a love of the gay, the fast, life: modern Japanese, in fact, translate the word *Ukiyo-e* as 'Pictures of Gay Life'. Prints and books are replete with pictures of pleasure-parties in the town, the countryside or along the river, the youth of both sexes freely intermingling and philandering, often to the accompaniment of music, and with the *sake*-kettle always ready to hand. The Yoshiwara, the brother quarter, was a constant preoccupation of the Ukiyo-e artists, and the *Kabuki* theatre provided almost as many subjects. These, with *kacho* (pictures of birds and flowers), and landscape, a later, nineteenth-century development, form the subject-matter of the prints, a little more detailed consideration of which is an aid to appreciating the nature of the people, and the art of the print-designers.

The Courtesan and the 'Gay Life'

The courtesan was, in all senses of the word, a public figure. Accepted by the authorities as an inevitable feature of town life – the large numbers of officials quartered in Edo without their families, and the lack of romance in the prearranged marriage of the country were partial causes – the Yoshiwara in Edo and similar establishments there and elswhere were set apart for licensed prostitution. The Yoshiwara became the haunt of most of the artists and writers of the time in seach of 'copy', for the town-dwellers were always avid for pictures of the 'Green-Houses', of the colourful life of this world-within-a-world, and especially for portraits of the denizens, the courtesans, from the *tayu*, the queen of her calling, and the *oiran*, the next in the hierarchy, down to the acolytes of the profession, the *shinzo* and *kamuro*.

The higher-class courtesans, destined for those of high rank or great wealth, were trained from children to become fit consorts for such men. They bore themselves like princesses, whose accomplishments they emulated, learning to speak the ancient poetic language, practising the arts of music, painting and poetry, and carrying themselves in their gorgeous apparel with regal grace.

Various factors led to their popularity with the colour-print artists, apart from the public demand for pictures of the reigning beauties. Though these were never portraits in our sense of the term, they were unquestionably fashion-plates, and to a nation such as the Japanese, where both men and women were absorbed in matters of dress, the patterns and colours of silks, this was a major attraction. In a celebrated book of 1776, 'Mirror of Fair Women of the Green-Houses', illustrated by Shigemasa and Shunsho (Fig. 22), the publisher, Tsutaya Jusaburo, calls attention in a preface to the Japanese artist's preoccupation with 'the fashions of costume and hairdressing prevalent at each age, which pass as rapidly as the infant growing to manhood'; and from Moronobu onwards, the changes in dress fashions, in the motifs of the silk-designers, but especially the alterations in coiffure styles, are marked enough to date the prints with some reliability. The features of a girl's face often seemed of less concern to the artist than the set of her hair, the drawing of which, with its complement of combs, was always given in considerable detail. One could easily believe that with the Japanese the hair was in truth 'a woman's crowning glory', and the beautiful, and often eccentric, shapes into which it was forced, play a large part in the pattern of the print-designers' compositions.

But the sway of fashion in Japan was not limited to dress or coiffure: the prints give clear evidence of the vogue of certain physical types: the tall, majestic figure of the Primitives giving way gradually to the improbable *petite* of Harunobu, and this to the immensely tall and slim forms affected by Kiyonaga, Eishi and Utamaro. In the

artists' drawings, there was rarely any truth to the actual Japanese feminine form: in this again the artists showed their complete independence of the dictates of nature. The actual build of the average Japanese woman was, and is, a little shorter than that of her Western counterpart, but this did not prevent the artists from imparting to their models the ample majesty of the Parthenon 'Fates', or the dainty sprightliness of Watteau's shepherdesses, or the willowy grace of Modigliani's attenuated creatures: all in accordance with the canon of porportions dictated by the current leaders of fashion.

The 'Pleasures of Edo' is the title on scores of colour-print books and on a multitude of prints. Usually they depict the gallants escorting courtesans and their more virtuous associates, the geishas, in the well-known thoroughfares of the town, making their way to a popular rendezvous, tea-house or theatre; or in pleasure-boats on the Sumida river, the favourite setting for trifling amours and mild debauchery; or in the lovely gardens abounding in the purlieus of Edo, rapt in admiration of the flowering cherry trees, perhaps, or of the red maple leaves floating on a pool.

The town of Edo, itself like a huge pleasure-garden with impermanent-looking houses and bridges of fanciful shape spanning the river, was often *en fête*. Each month had its own festival celebrated with spectacular processions and pageantry, regattas on the river and firework displays, providing the Ukiyo-e artists with wonderful opportunities for compositions crowded with figures in flamboyant costumes, and alive with the gaiety and abandon of carnival.

At other times, we are given glimpses of the interiors of the Yoshiwara apartments, of the ceremonial of the 'courtship' preceding 'full knowledge'. Or the women are seen alone, idling the day away in decorous pursuits, writing long love-letters, displaying a new dress to companions, amusing themselves with pet animals or with battledore or yo-yo.

As the eighteenth century waned, there were other reasons for the popularity of the Yoshiwara among the artists and intellectuals generally. The unrest in the country caused by the ferment against the Shogunate led to repressive measures, and many of the men who sowed the seed that came to fruition in the revolution of 1868 found sanctuary in the precincts of the Yoshiwara, which became a cloak for the 'underground' movement, a place where freedom of thought and speech was possible despite harsh laws. In the luxuriously appointed quarters of the Yoshiwara, literary wits of the time like Kitao Masanobu and Jippensha Ikku (themselves both designers of prints), Utamaro, Toyokuni and their fellow artists, rubbed shoulders with the political firebrands seeking refuge there, and something of the charged atmosphere, the undercurrent of violence beneath the froth and sparkle of wit, gives the prints of the late eighteenth century a strangely disturbing character, a sort of *fin-de-siècle* sophistication new to Japanese art.

The Theatre

The theatre was, to the Edo commoner, all part of the 'Gay Life'. It was recorded assiduously by the Ukiyo-e artists, and some of the finest prints of the school are of actors in character.

The *Kabuki* theatre originated in the seventeenth century, only a few decades before the Ukiyo-e school began to find its outlet in the illustration of books. It was a composite, combining features from the old dances of Japan, from the classical *No* drama of the aristocracy, and from the already popular puppet stage. The *Kabuki* was a typical product of the new class: the stiff brocade and ritualistic dance of the *No* plays were replaced by fashionable silk and greater freedom of

movement, the recondite acted poetry gave way to something more nearly approaching realism in speech and action, even though to our intelligence both are still mannered and non-naturalistic. The art of the *Kabuki* theatre was as much visual as literary, partaking in some degree of the character of our ballet, though the movements were more restricted, the drama more intense, and the tempo so slow that at times the stage seemed to present a series of colourful tableaux. The plays were sanguinary, full of violence, heroics and bathotic situations, and hardly stand high as literature, but they provided magnificent material for the colour-print designers, certain sub-schools coming into being primarily as recorders of stage performances and as portrait-makers of the actors.

Most Ukiyo-e artists at one time or another took the stage as their subject, but to three families of artists in particular we are indebted for the finest work in this sphere: the Torii, of whom Kiyonobu, Kiyomasu, Kiyohiro, Kiyomitsu and Kiyonaga are the great masters; the Katsukawa, Shunsho and his pupils Shunko and Shunyei and others less well known; and the Utagawa, of whom Toyokuni, Kunimasa, Kunisada and Kuniyoshi are the principal designers.

In their prints, little attempt is made to give the scene of a play, a few unobtrusive 'props' being all that was required to set the stage for the fanatical theatre-goers. Normally, the prints depict either a single actor, or less often, two, in character, and from Kiyonobu onwards, the artists show a wonderful ingenuity in composing a rhythmic design based on a single figure, or two in a sort of *pas-de-deux*. As on the Elizabethan stage, only male performers were permitted, but certain families of actors specialized in female parts, and judging by the prints, their impersonations seem to have been deceptively life-like. Few can resist the charm of the 'girl' holding an umbrella in Buncho's magical print (Plate 21) and it is hard to believe that the model for such feminine grace of movement was a male actor.

Shunsho is one of the greatest masters of the actor-print, and at his best delights us with the dancing arabesque of his figures against a slightly indicated backdrop, using a simple outline and flat tones of soft harmonious colouring. Yet, despite the absence of what we call realism, he gives us a convincing picture of the actors of the Edo theatres. One Western writer, Mr Osman Edwards, familiar with the *Kabuki* performances, wrote, 'To watch act after act of their spectacular tragedies is like looking through a portfolio of their best colour-prints.'

The prints of Sharaku need special mention, because although founded in the tradition of the theatrical colour-print, they have qualities that distinguish them at once from all other prints of the same order. The intensity of characterization, the forcible draughtsmanship, the bizarre and sinister harmonies of colour, accentuated by the dark mica-grounds of most, compel attention although they may disturb or even revolt us. The staring eyeballs, the unnatural grimace, are no more than an interpretation of the intensity of expression affected by the actors, though in some of the prints there are, I think, the marks of a master who, like Cézanne sometimes, has to struggle to express himself, hampered and angered by the limitations of his medium. Perhaps the most astonishing thing to relate in connection with Sharaku's prints, not unconnected with this sense of a giant wrestling with an intractable medium, is that they were all produced for plays performed from the fifth month 1794 to the first month 1795, and that there is no evidence to show that the artist had ever designed a colour-print before that date.

Kacho-e and Landscape

From earliest times, the Japanese people were united in an unfeigned devotion to nature. Literature, legend, painting, ceramic and textile all bear testimony to an innate love of flowers and trees, birds and animals, and all the natural features of the countryside. The rising of the new moon was celebrated by gatherings of people who composed lyrics as they watched the sky; the flowering of the cherry trees was made the occasion for 'viewing-parties'; the red leaves of the autumn maples, and the first falls of snow, brought admiring groups into the countryside; the mountains and lakes of their beautiful land were literally worshipped – who can forget the picture in Hokusai's book. 'The One hundred Views of Fuji' of an old man kneeling before a circular window framing a distant view of Fuji and flinging back his head in an ecstasy of delight at the vision? Poems extolling the Peerless Mountain, Lake Biwa and the lesser known features of every province, are legion.

In art, this deep feeling for nature gave rise to a pure landscape art long before such a thing appeared in European painting, and also to paintings of 'birds and flowers', *kacho-e*, that really have no counterpart in our art at all. The greatest painters of the Kano and Chinese schools excelled in paintings of these two kinds, and their works were revered with something next to idolatry, the finest resting in the temples as objects of devotion.

As will be mentioned shortly, the Ukiyo-e artists were inclined to deal in a rather cavalier manner with the subjects hallowed by antiquity and traditionally associated with the aristocratic schools of painting, but in their landscape and *kacho* art, though still unmistakably Ukiyo-e in timbre, the note is often of great sincerity, and the humble prints challenge comparison with the paintings of Sesshu and Motonobu, So-ami and Chokuan, and other giants of the past.

There are early *kacho-e* from the hands of such primitives as Kiyomasu, Shigenaga and others, whose drawings of hawks, for instance, in striking black line only, are often of an impressive magniloquence: but Harunobu and Koryusai, Utamaro, Hokusai (Fig. 7) and Hiroshige, with the greater resources of the colour-print proper at their command, excelled in this field, producing exquisite designs of flowers, birds and animals that exemplify the astonishing power of the Japanese to synthesize and conventionalize natural forms, to bring them into an ordered pattern, without destroying the illusion of life, of actuality.

The art of the popular school was primarily in *genre* painting, manners and modes of the ordinary life of the day, and from the earliest book illustrations it was habitual to set the scene with a glimpse of tree or stream, the outline of tea-house or Yoshiwara, in the background. However, landscape, as an independent art, appeared late in the prints, though Toyoharu with his Europeanized *Uki-e* 'bird's-eye-view' prints may be an exception to the rule. By the time of Kiyonaga, Eishi and Utamaro, the background was often given greater prominence, and in their *plein air* pictures, the pleasure-gardens, the streets of Edo, the river-front, are effectively sketched in. Utamaro, in some albums of about 1790, produced some prints that are pure landscape, but it was left to Hokusai and Hiroshige to develop this last achievement of the colour-print art, one that, with our natural bias towards landscape art, delights us more spontaneously than any other.

Hokusai's landscape prints, though based on the age-old traditions, are daringly innovating, and owe much of their *éclat* to the colour-print technique. This medium, imposing broad treatment, firm outline and flat washes of colour, seemed to inspire him to design in a synoptic manner, disdaining the accidents of topography

and weather the better to achieve the essential hill, the eternal sea: though, in true Ukiyo-e vein, it is only rarely that man is absent, dwarfed and intimidated though he may be by the elemental forces and forms around him.

Hiroshige is a milder and gentler spirit altogether, the figures, the human element, loom larger in the foreground, and generally we feel that we are in a land where rain and moonlight are much as they are with us. Our sympathies are won over not only by his artistry, but by the sense that, though essentially Japanese, he is in some indefinable way closer to us, in style and sentiment, than any of his forerunners, and his brush-drawings bring this out, if anything, more clearly.

Legend and History

It is testimony to that strange duality in the life of the Japanese to which reference has already been made, the indulgence in all forms of sensuous pleasure and an ardent appreciation of the arts against a background of violence, fanatical loyalty and revenge, to us wholly barbaric, that the Ukiyo-e artists often turned from the blandishments of the 'Green-Houses' and the theatre to subjects from heroic legends, and particularly from the bloody events of mediaeval history, barely distinguishable themselves in the passage of time from the most improbable of the legends.

Chief among these legendary histories, or historical romances, are those dealing with the civil wars of the middle ages between the two dominant clans, the Minamoto and Taira. The stirring events of these wars, the great battles and the individual feats of chivalry and derring-do recur again and again, few artists being able to resist this type of print, perhaps because an innate nationalistic pride in the past led to the unfailing popularity with the public of such depictions. Even those artists whose charm lies in an essentially feminine grace, Harunobu, for instance, or Shunzan, became changed spirits as they buckled on the cumbrous old armour and turned manfully to the warlike themes, the fight on Gojo Bridge, for example, between Yoshitsune and the giant Benkei – a favourite subject – or Hachimantaro, heroic youth of the Minamoto clan, performing prodigies of valour.

Parody, Travesty, Burlesque, and Analogue

The newcomer to Ukiyo-e art will often be puzzled by the artists' oblique manner of illustrating a given theme, and by the even less straightforward manner of entitling prints. Subjects reverently painted by artists of the established schools are whimsically enacted by courtesan and paramour in 'modern dress'; and going further, by an odd transmogrification, classical landscapes and famous views are personified by women of the Green-Houses, whose trivial occupations are ingeniously made to suggest, by remote anology, famous places and events, and the classical painters' representations of them.

The Seven Famous Scenes in the life of the poetess Komachi were handled in this way by nearly every Ukiyo-e artist of note: a mother and child, for instance, looking in a mirror, are made to do service for the 'Komachi and the Parrot' scene, the pun-loving Japanese seeing an immediate connection between the 'Echo-poem' returned by Komachi to the Emperor Yosai, using all the same characters save one that comprised his own poem, and the two reflected faces in the mirror. Even more popular was the linking of the traditional 'Eight Views of Lake Biwa' with scenes in domestic life: in the print of Harunobu reproduced here (Plate 15) there is a typical Ukiyo-e 'take-off' of the 'Evening Bell of Miidera'.

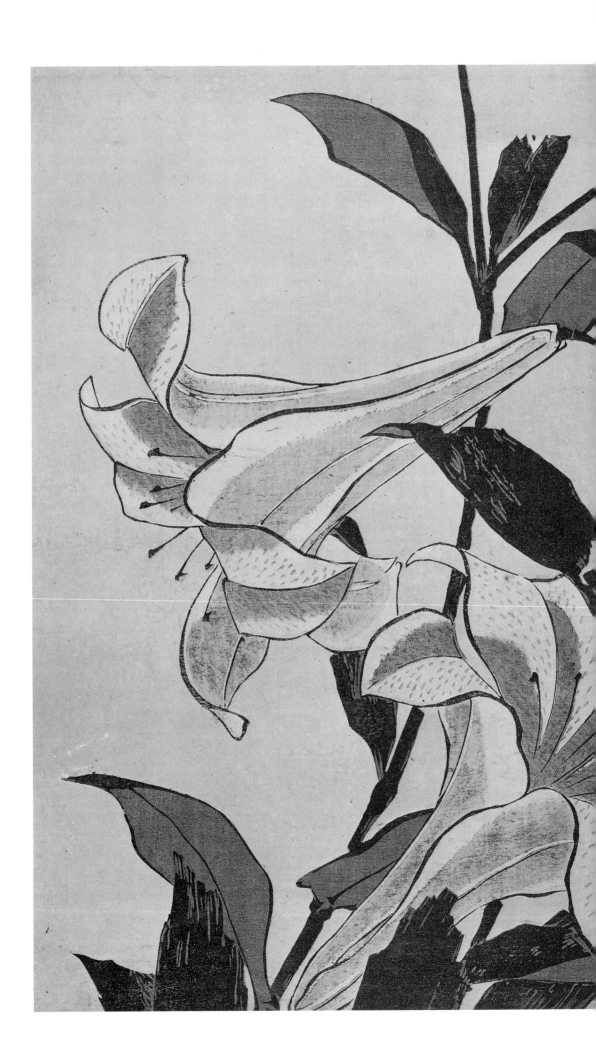

Fig. 7
Katsushika Hokusai:
Lilies
From the series of 'Large
Flowers'. 25.4 x 36.2 cm.
Private Collection

Other favourite subjects with the Kano painters, the jolly madmen Kanzan and Jittoku, traditionally shown as ragamuffin figures, one with a scroll, the other with a besom broom, are represented by girls attired *à la mode*, a love-letter taking the place of the scroll, and as often as not, a *samisen* serving for the besom. The six famous 'jewel-rivers' of Japan were invariably personified by gorgeously apparelled women of the Yoshiwara, some pattern of their robe or some action of theirs, whose significance may be lost upon us, giving the locality of each river.

Parody and travesty are hardly exact words for this sort of thing, though occasionally the playful treatment of well known stories or legends amounts almost to burlesque: as for example, the enactment of the tenth-century court scenes from the Genji Romance by fashionable ladies of the demi-monde, and the representation of scenes from the popular melodrama 'The Forty-seven Ronin' by pictures of domestic squabble or low-life courtship, far-fetched parallels to which a clue was often given by a small inset drawing of the actual scene burlesqued.

The Art of Ukiyo-e

The study of a piece of music, a *Lied* of Hugo Wolf's for example, an analysis of the score and a translation of the lyric, brings us only a little way towards an appreciation of the musician's art, which lies in the fusion of words and accompaniment, and can be judged by the sounds alone. Having glanced at the environment of the Ukiyo-e artists, the class of people for whom their art came into being, the technique and the subject-matter of the prints, there is still something to be added concerning the especial aesthetic appeal of the prints, an appeal as difficult to translate into words as that of rhythm, melody and counterpoint. Primarily, it is a matter of pure design, of the fusion of line and colour, subject and composition, into 'pictorial music', addressed to our sight as the *Lied* is to our hearing.

Of the pictorial art of few other nations can it be said that it compares with that of the Japanese print-designers in so nearly achieving that aspiration towards a 'condition of music', tardily accepted in Europe as the ultimate aim of graphic art. A knowledge of the language, customs, history, literature and legends of the country may in some cases aid our appreciation, but at other times may actually interfere with the more purely emotional acceptance of the print as a work of art, returning a magic amalgam into its separate elements.

Founded, for all its revolutionary character, in a tradition of painting that had never adopted mere representationalism as one of its tenets, and aided by a medium that inhibited any tendency to elaborate beyond firm outlines and flat tones of colour, the art of the Ukiyo-e artists stands or falls ultimately on an assessment of its design: and there are many who will agree with Laurence Binyon and O'Brien Sexton whose considered opinion was that 'As pure design, this body of work is unrivalled in any other country, unless perhaps by Greek vases.'

Given a space to fill, the Japanese designers seem to have had an innate gift for decorating it in a manner felt by us to be inevitable. This is brought home most clearly, perhaps, in the *kacho-e* of Harunobu, Koryusai, Utamaro and Hokusai, in which the shapes and colours of bird and flower are brought with masterly skill into compositions that satisfy us like rounded melodies, and are unerringly given the perfect *mise-en-page*. In the process, just as the faces of the courtesans are reduced in other prints to a few expressive lines, the minutiae of fur and feather may be sacrificed, and botanically the flowers might not convince Bentham and Hooker: but the drawings bring out

the essentials, the plant really seems to be growing, the bird is unmistakably alive and capable of flight.

But this genius for synthesis is not limited to their designs for *kacho-e:* its greatest triumphs were in the drawing of the human form. 'Art is first of all unity of impression,' wrote Fenollosa, 'but into this unity can be thrown and melted every serviceable form that generous nature can supply.' In the figure designs, comprising by far the greater proportion of the prints, there is the same reduction to essentials, the same insistence on pattern. The relation of figure to figure may seem accidental, the pose of each naturalistic, but in reality, the arrangements are quite artificial, as much bent to the artist's will as the artfully placed spray of flowers or the bird on the wing.

In landscape, too, the utmost ingenuity and invention are brought to bear in composition. Hokusai is undoubtedly supreme in this power of reducing the disorder of nature to a formal pattern that still has the impress of actuality and is never mere conventionalized form. The series of forty-six prints entitled 'The Thirty-six Views of Mount Fuji', the cone-shaped mountain appearing in each print like a *leitmotiv*, is a display of virtuosity akin to the Diabelli Variations of Beethoven: and for daring composition even these are excelled by the series of 'Waterfalls'. Hiroshige combines a faculty for pictorial pattern with great use of the unusual viewpoint. The snow-covered fields around Edo are seen from a great height with the eyes of an eagle, whose outspread wings fill the upper part of the design (Fig. 8); the Iris Gardens of Horikiri are glimpsed through the irises themselves, brought close to the viewer's eyes; the bow moon, in a famous print, is seen low down in the sky between precipitous cliffs that soar to each side of the panel (Plate 46).

In these achievements of the figure-designers and landscapists in the realm of composition, their sacrifice of detail and bold synthesis of natural forms, their adoption of the unusual angle or viewpoint in the cause of a telling design, in all this there may seem little that is novel to us today. But the impact and effect on European art in the nineteenth century cannot be over-estimated. The growth during the century among European artists of the conception of an art based on, rather than tied to, nature, the breaking away from the dogma of representing 'things as they are seen', was due indirectly to the lesson of the East: and many painters were directly influenced by the design of the Ukiyo-e artists, their manner of employing human form and landscape feature as elements of a pictorial pattern. Degas, Manet, Gauguin, Van Gogh, Toulouse-Lautrec, Bonnard, Beardsley and the poster-designers the Beggarstaff Brothers – to take a number of artists at random – all show indebtedness at one phase or another of their work to the designers of the Japanese colour prints.

By a sad turning of the tables, the influence of Western art on the Japanese in the nineteenth century was to cause first a flirting with, then a complete subjection to, the very representational method already, by their example, discredited in the West. Water-colour was forsaken for oil-paint, quite inimical to their native technique, and the traditional styles of painting that had prevailed for centuries and given rise to a body of painting unique in character, were thrown over for imitations of European methods, mostly of a debased 'photographic' type.

But the influence of alien models can hardly be held to account for the deterioration in the art of the Ukiyo-e school. Even before the country was opened up to foreigners in 1853, in fact from the beginning of the century, there were signs of a falling off from the high standards that had prevailed until then, and the broadsheets, issued now in vast numbers for an increasingly uncritical public, gradually became poorer in the quality both of the designs and of the colour-printing. Hokusai and certain of his pupils; Hiroshige; Kuniyoshi and,

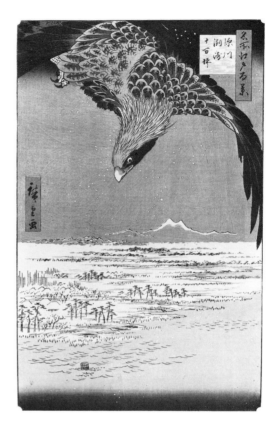

Fig. 8
Ando Hiroshige: An Eagle above the Snow-covered Plain at Suzuki, Fukagawa
From the 'One hundred views of Edo'.
35.6 x 24.1cm.
Private Collection

for a time, Kunisada, continued to produce fine prints, despite the evil effect on the colour-printing caused by the replacement of vegetable colours by aniline dyes of foreign manufacture; but by the time of the Revolution of 1868, the art of the Ukiyo-e colour print was dead. There were attempts to revive the art later in the century, and the block-cutters, at least, showed that they had not forgotten their craft: but the designer's art had been finally vitiated by contact with the West, and few of the later prints rise above either ineffectual prettiness, or violently coloured melodrama.

Select Bibliography

General Works

Laurence Binyon, *A Catalogue of the Japanese and Chinese Woodcuts . . . in the British Museum*, London, 1916.

Laurence Binyon and J. J. O'Brien Sexton, *Japanese Colour Prints*, London, 1923.

Louise Norton Brown, *Block Printing and Book Illustration in Japan*, London and New York, 1924.

D. G. Chibbett, *The History of Japanese Printing and Book-illustration*, Tokyo and Palo Alto, 1977.

R. A. Crighton, *The Floating World of Japanese Popular Prints, 1700-1900*, London, 1973.

T. and M. Evans, *Shunga: The Art of Love in Japan*, London, 1975.

Arthur Davidson Ficke, *Chats on Japanese Prints*, London and New York, 1915.

Margaret Gentles, *The Clarence Buckingham Collection of Japanese Prints: Vol. II, Harunobu, Koryusai, Shigemasa and their followers and contemporaries*, Chicago, 1965.

Helen C. Gunsaulus, *The Clarence Buckingham Collection of Japanese Prints: Vol I, The Primitives*, Chicago, 1955.

Matthi Forrer, *Egoyomi and Surimono*, Uithoorn, 1979.

J. Hillier, *The Japanese Print: A New Approach*, London, 1960.

J. Hillier, *Japanese Prints and Drawings from the Vever Collection*, 3 vols, London, 1976.

Richard Lane, *Masters of the Japanese Print*, London, 1962.

James A. Michener, *Japanese Prints from the Early Masters to the Modern*, Rutland, Vermont and Tokyo, 1959.

Laurence P. Roberts, *A Dictionary of Japanese Artists*, Tokyo and New York, 1976.

H. P. Stern, *Master Prints of Japan*, New York, 1968.

F. A. Turk, *The Prints of Japan*, London and New York, 1966.

Tsuneo Tamba, *Reflections of the Cultures of Yokohama in Days of the Port Opening*, in Japanese with English subtitles, Tokyo, 1962.

Works on Individual Artists

Arthur Davidson Ficke, 'The Prints of Kaigetsudo', *The Arts*, Vol. IV, No. 2, New York, 1923.

Harold G. Henderson and Louis V. Ledoux, *The Surviving Works of Sharaku*, New York, 1939.

J. Hillier, *Suzuki Harunobu*, Philadelphia, 1970.

J. Hillier, *Hokusai: Paintings, Drawings and Woodcuts*, London, 1955 and 1978.

J. Hillier, *Utamaro: Colour Prints and Paintings*, London, 1961 and 1979.

Chie Hirano, *Kiyonaga: A Study of his Life and Works*, Cambridge, Mass., 1939.

Sadeo Kikuchi, *Utagawa Toyokuni*, English translation by Roy Andrew Miller, Rutland, Vermont and Tokyo, 1957.

B. W. Robinson, *Kuniyoshi*, London, 1961.

Edward F. Strange, *The Colour-prints of Hiroshige*, London, 1925.

Seiichiro Takehashi, *Kaigetsudo*, English text by Richard Lane, Rutland, Vermont and Tokyo, 1959.

Charles S. Terry, *Hokusai's Thirty-six Views of Mount Fuji*, Tokyo, 1959.

D. B. Waterhouse, *Harunobu and his age: The Development of Colour Printing in Japan*, London, 1964.

List of Illustrations

Colour Plates

Text Figures

Comparative Figures

Returning from a Flower-Picnic

One of a series 'The Fashion of Flower-Viewing at Ueno'. Unsigned. Ink-print, hand-coloured. 26.7 x 41 cm. c.1680. London, British Museum

Fig. 9
**Hishikawa
Moronobu:
Interrupted Lovers**

From an erotic book
'Love's Pleasures' dated
1683. 22.2 x 32.4 cm.
Regensburg, Franz
Winzinger Collection

Hishikawa Moronobu (1625?-94), after following for a time the calling of his father, an embroiderer, received training as a painter in both the Tosa and Kano schools. It is not known by what means he came to develop his own unmistakable Ukiyo-e style, though it was foreshadowed by book-illustrations of one or two anonymous masters of the 1660s, from whom he must have learnt much even if he was not actually a pupil. From about 1672 onwards, Moronobu illustrated upwards of one hundred books (Fig. 9) and towards the end of his life designed numerous separate broadsheets, setting a style of drawing for the woodcut that affected the work of all subsequent Ukiyo-e print-designers. Of Moronobu's pupils and followers, Sugimura Jihei, Moroshige, Morofusa and the first Torii masters were the most successful.

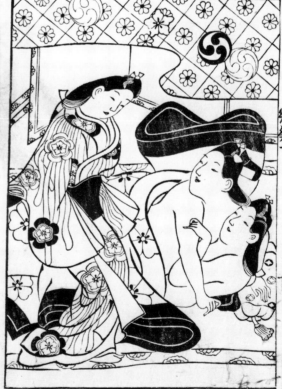

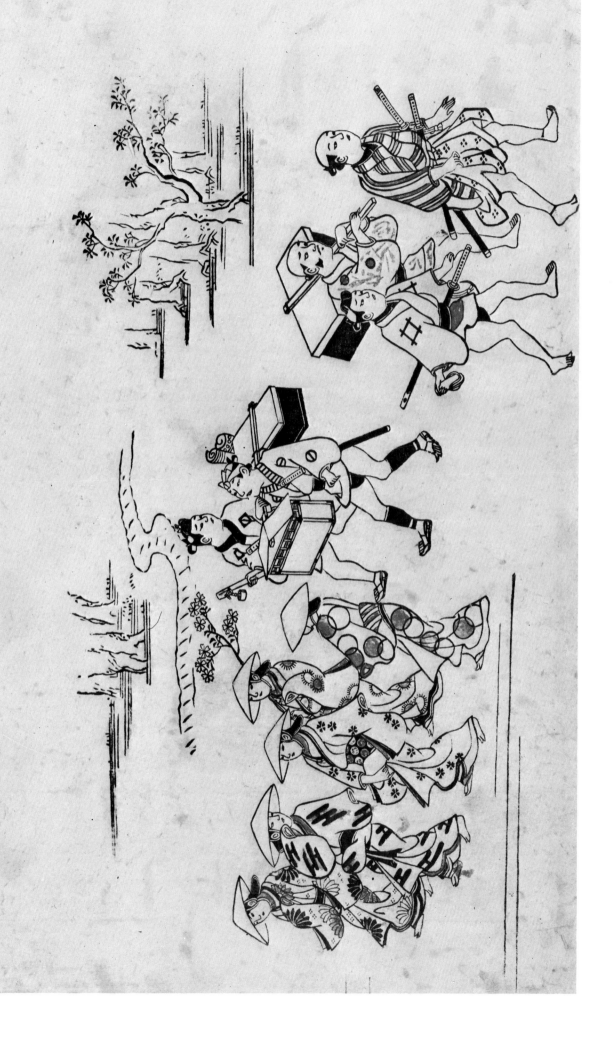

The Actor Shinomiya Heihachi in a Samurai Role

Unsigned. Tan-e. 51.8 x 30.5cm. c.1700-5. The Art Institute of Chicago

Torii Kiyonobu I (1664-1729) came of an Osaka theatrical family, and assisted his father in painting sign-boards for the theatre in Edo, to which town the family moved in 1687. Soon after, Kiyonobu began illustrating books and about 1695 designed his first actor-prints, which were immediately successful with the Edo public. The broad treatment of these early prints suggests the sign-board artist, though his style owed much to Moronobu. He is the founder of the Torii school of artists, noted principally for actor-prints. His late work cannot always be separated with certainty from that of the second Kiyonobu, but the earlier has a swirl and frenzy of design that is entirely individual. His broadsheets are all ink-prints *(sumizuri-e)* with or without the addition of hand-colouring. At this early stage the colouring was often *tan*, a red lead pigment, which gave the name *tan-e* to prints so coloured.

Kiyotada, Kiyotomo and Chincho are among the pupils of Kiyonobu I working in the early decades of the eighteenth century. Katsukawa Terushige, of whom little is known, was apparently a pupil of Kiyonobu I, and is known by a few rare prints of unusual merit.

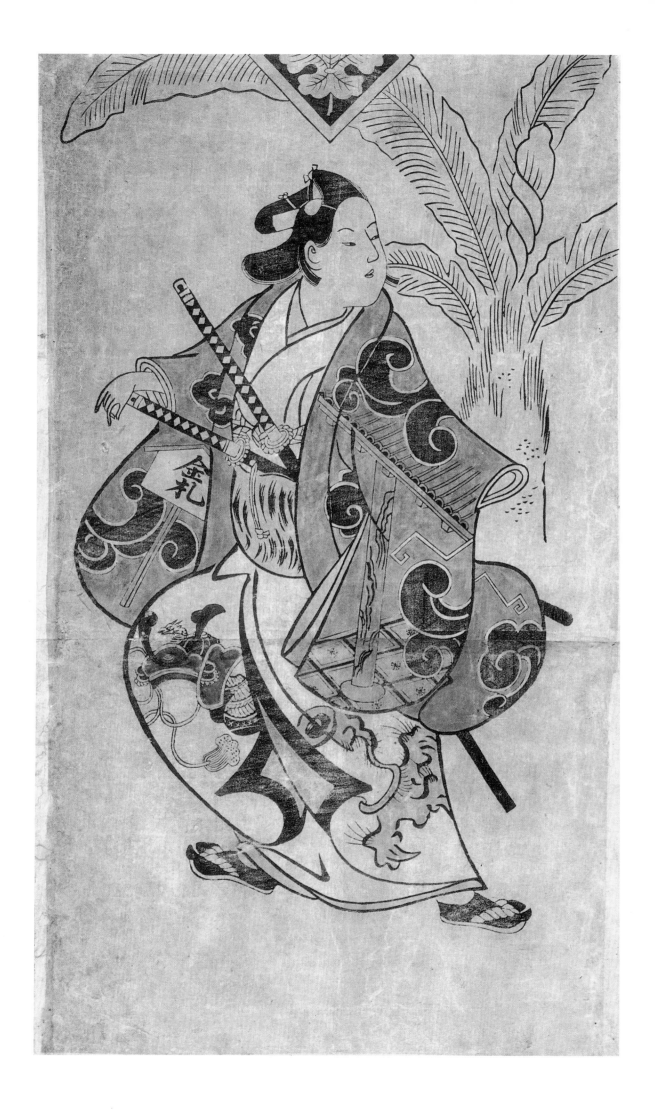

SUGIMURA JIHEI

The Insistent Lover

Album print, Sumizuri-e, hand-coloured. 27.3 x 40.6 cm. c.1685.
The Art Institute of Chicago

Sugimura Jihei was active in the late seventeenth century, but very little is known of this contemporary of Moronobu. His work comprises a number of prints and albums, the latter mainly erotic in content, which appeared between 1685 and 1698. His style is close enough to Moronobu's for his prints to have have been ascribed to that master, some having been identified only when his own names were found worked into the design. He makes most effective use of the disposition of the blacks in conjunction with a rich linear decoration, much in the way that Beardsley did two hundred years later.

In *The Insistent Lover* a man with the *mon* (crest) of Matsushima Kichisaburo is trying to restrain a woman from leaving him; a maid-servant is in the background. The name Jihei is on the man's belt, and Sugimura forms part of the girl's *kimono* design.

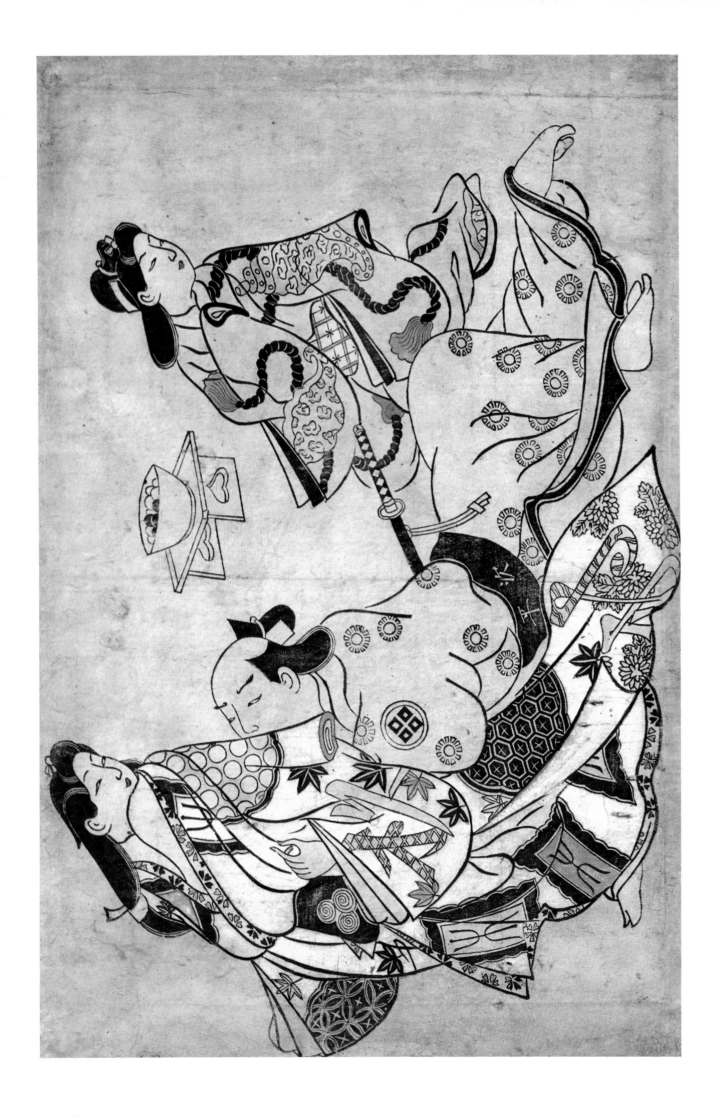

Standing Courtesan

Sumizuri-e, hand-coloured. 54.6 x 31.1 cm. c.1714-15. San Francisco, Grabhorn Collection

Kaigetsudo worked in the early eighteenth century. The rare and beautiful prints signed with this name are the work of three artists, pupils of one Kaigetsudo Ando. Their prints, almost invariably of a single courtesan in heavy robes patterned with the then fashionable large motifs, are among the most impressive of the whole range of Japanese art. The prints are signed by Anchi, Doshin, Dohan.

Plate 4 is signed *Nihon Giga* ('Japanese artist drawing for pleasure') *Kaigetsu Matsuyo* ('needle of the pine', i.e. pupil, of Kaigetsu) *Anchi*.

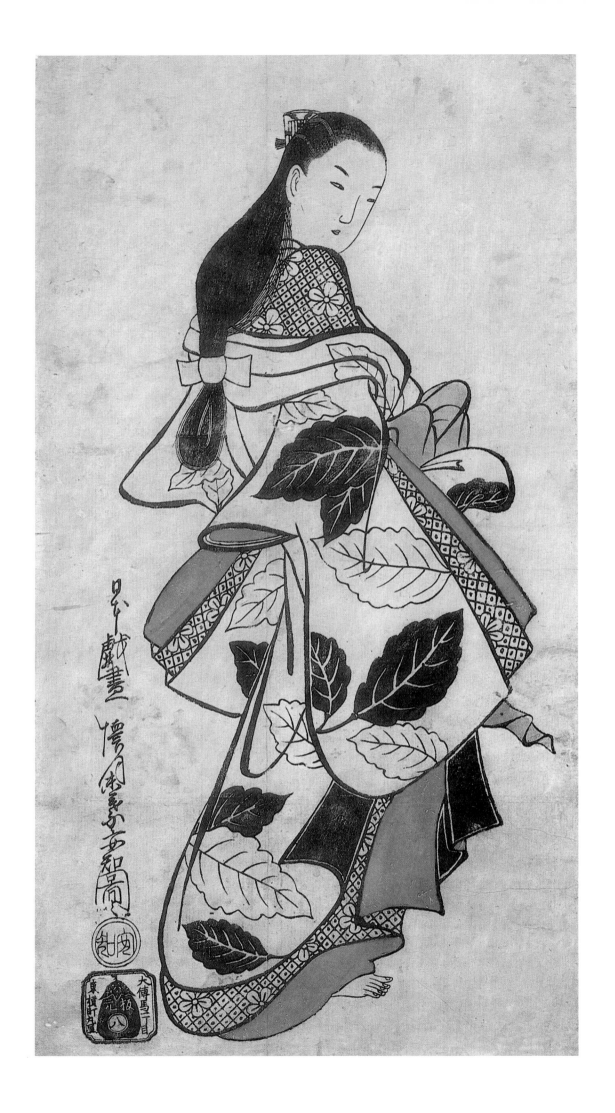

The Actor Nakamura Senya in the Role of Tokonotsu

Tan-e. 58.4 x 33 cm. 1716. Hawaii, Honolulu Academy of Arts, Michener Collection

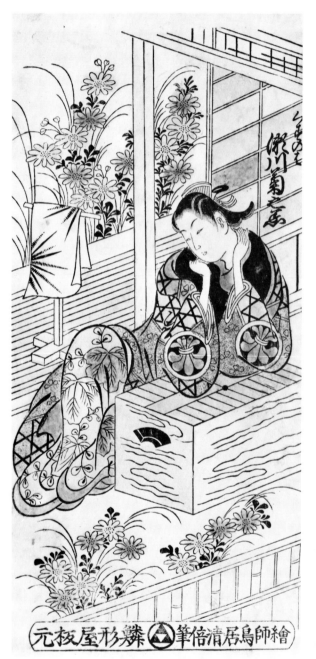

Torii Kiyomasu I (1696?-1716?), Torii Kiyomasu II (1706-63); modern scholarship contrives to make two Kiyomasu, as it had already made two Kiyonobu, but there has never been complete agreement on the relationship between these artists. The following is one theory. The first Kiyomasu was short-lived, and Kiyomasu II (Fig. 10) took over the name upon his death. The style of both is typical of the Torii school and is seen to pass through several phases: the truly primitive ink-prints, often hand-coloured; lacquer-prints; and, in the last stages, two-colour prints. Their work was devoted very largely to the stage.

Fig. 10
Kiyomasu II: The
Actor Segawa
Kikunojo I as
Kuzunoha in a Play
Performed in 1737

Sumizuri-e, hand-
coloured. 31.8 x 15.2 cm.
Private Collection

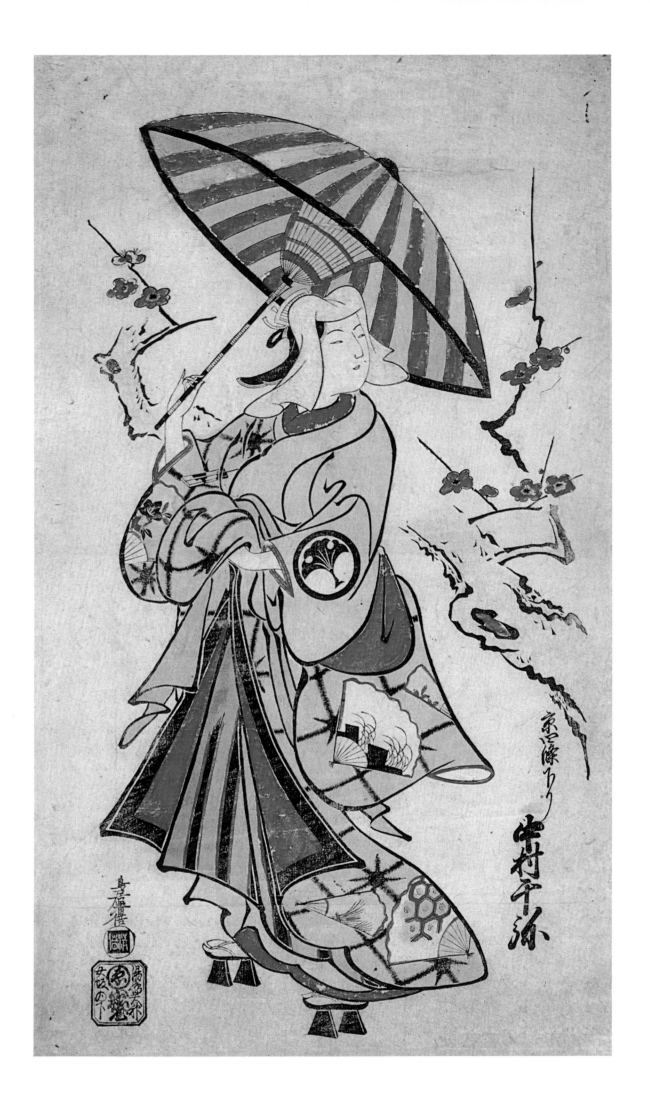

OKUMURA MASANOBU

The Love-Letter

Hand-coloured print. 61 x 24.8 cm. c.1748. London, British Museum

Fig. 11

Okumura Masanobu: A Perspective View of the Main Street of the Yoshiwara viewed from below the Great Gate

Sumizuri-e, hand-coloured. 33.3 x 43.5 cm. Private Collection

Okumura Masanobu (1686-1764) was one of the central figures of the colour-print movement. Moronobu, Kaigetsudo artists and Sukenobu all had their share in the formation of his style, though he is not known to have been the pupil of any one of them. Though frequently designing stage prints, he found his material, like Sukenobu, principally in the social life around him. As a bookseller in Edo, he knew better than most what the new public desired and was always in the forefront with innovations, with eye-catching devices. He is credited with the introduction of lacquer-prints and *Uki-e* ('perspective pictures'; Fig. 11) and was one of the first to design for the two-colour prints. He covers almost the whole of the Primitive period, beginning with large-scale ink-prints owing much to the Kiyonobu model, and ending with *benizuri-e* that in their graceful drawing and poetic sentiment point the way to Harunobu.

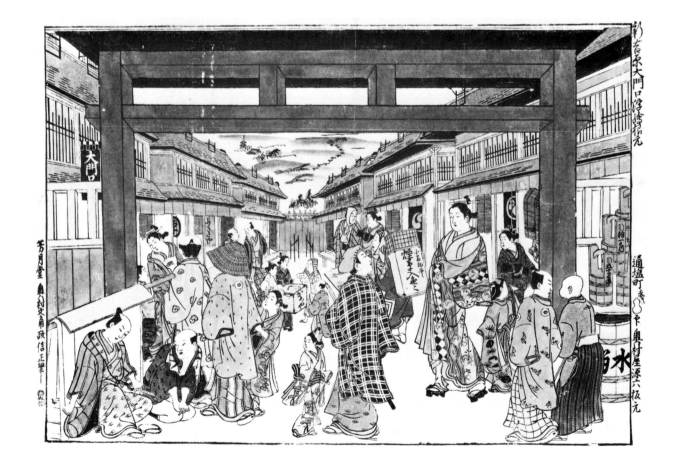

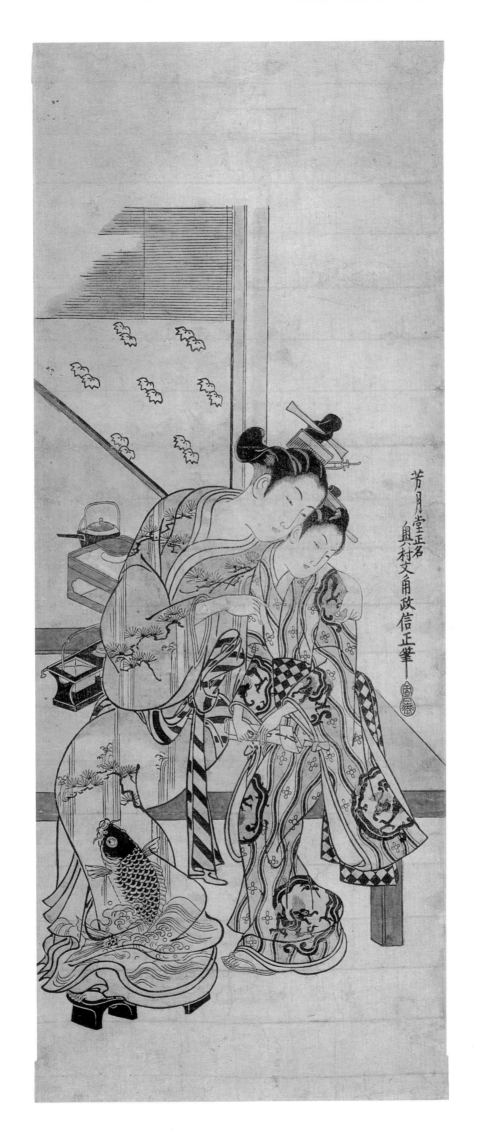

OKUMURA MASANOBU

Actors as the Ill-starred Lovers, the Incendiary Yaoya O'shichi and Kichisaburo, in a Play Performed in 1750

Benizuri-e (red and green). 44.5 x 30.8 cm. Boston, Museum of Fine Arts, William S. and John T. Spaulding Collection

Kabuki plays centred around a restricted number of themes, historical or quasi-historical events such as the 'Soga Brothers' Revenge' or the 'Forty-seven Ronin' (the *Chushingura*) or romantic affairs such as the love of Yaoya O'shichi for Kichisaburo. They provided the basis for countless plays over the centuries, the separate stories often inextricably and unaccountably linked in farragoes peculiar to the Japanese stage. This print was occasioned by a performance of a play in 1750 entitled *Tsujin Chimata Soga*, which coupled the themes of the disastrous love affair between Yaoya and Kichisaburo, which led to the burning down of Edo in 1683, and to the Soga brothers' revenge, which had taken place some centuries earlier.

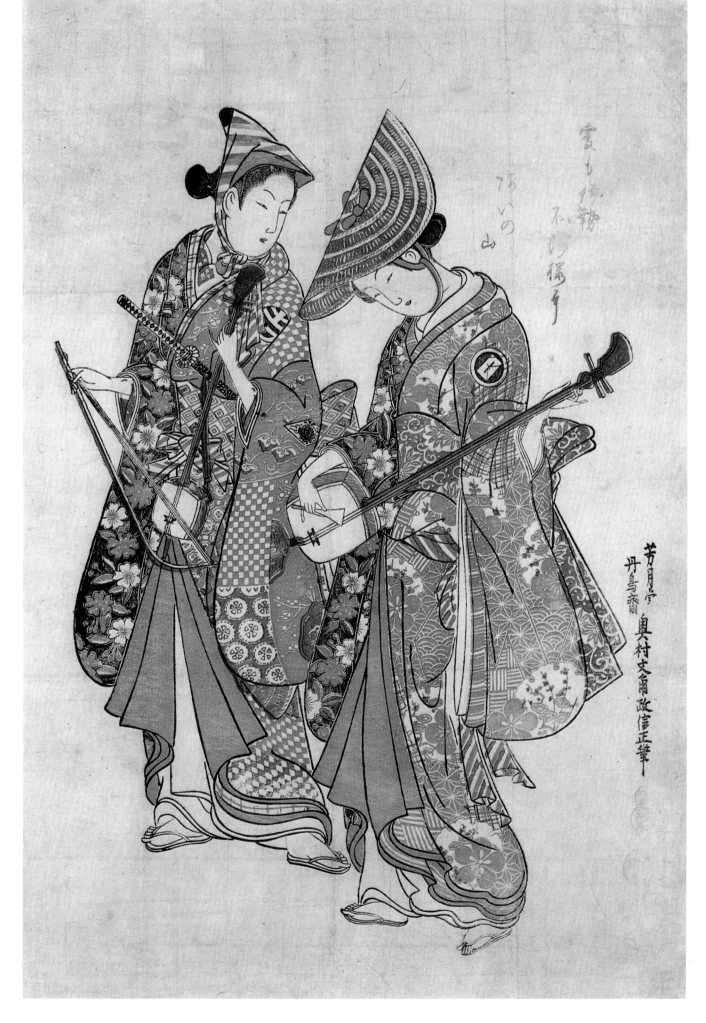

OKUMURA TOSHINOBU

Actors as a Flower-Seller and a Street Musician

Hand-coloured lacquer-print (Urushi-e). 33 x 16 cm. c.1740. London, British Museum

Fig. 12

**Mangetsudo:
'Cooling-off at the
Ryogoku Bridge'**

Three-sheet print.
Benizuri-e. c.1750. 28.9 x
14 cm. Private Collection

Less is known of Okumura Toshinobu (active c.1720-45) than even the majority of the Ukiyo-e artists. That he was a pupil of Okumura Masanobu can be deduced from his style, and that he was a master of enchanting lacquer-prints is brought home to us by his surviving works. But not a single biographical fact can be added. His main work was as a designer of prints recording Kabuki performances; he usually illustrated, from what we feel must have been the predilection of a gentle nature, the quieter passages of the plays, involving not more than one or two figures.

Mangetsudo was another gifted pupil of Okumura Masanobu (Fig. 12).

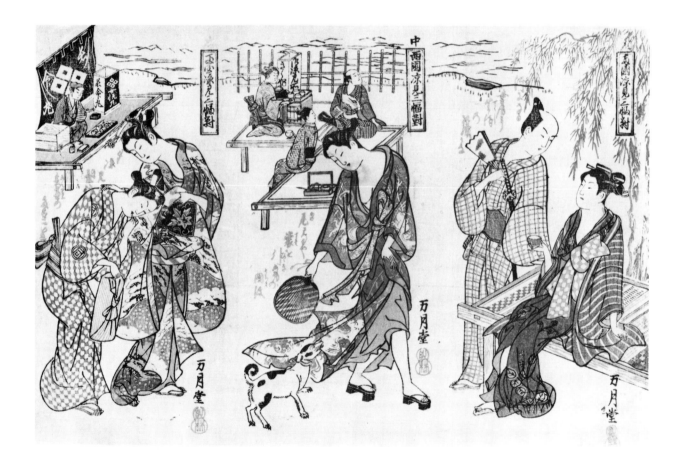

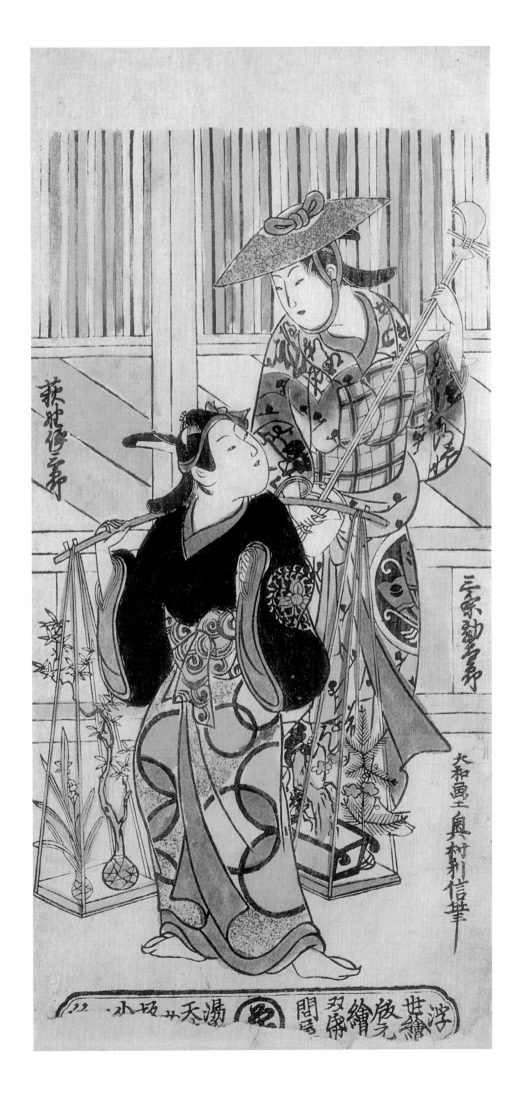

9

NISHIMURA SHIGENAGA

The Actor Sanyo Kantaro as a Tea-Seller

Lacquer-print. 33 x 15.2 cm. c.1725. London, British Museum

A book- and print-seller himself, Nishimura Shigenaga (1697-1756) was another of those artists who kept pace with the changing demands of his patrons. Beginning in the early manner of Masanobu with hand-coloured prints that never warranted his disparagement as 'a faded and weakened Masanobu', his two-coloured prints have a touch of fancifulness, 'an odd way of bringing grace out of apparent awkwardness', that explains in part their attraction for us. Toyonobu, Harunobu and Shigemasa are reputed to be among his pupils – sufficient claim to fame if he had no other. He is, like Okumura, a bridge between the Primitive period of *sumi-e* and two-coloured prints, and the full-colour period inaugurated by Harunobu in 1764. See also Plate 10b.

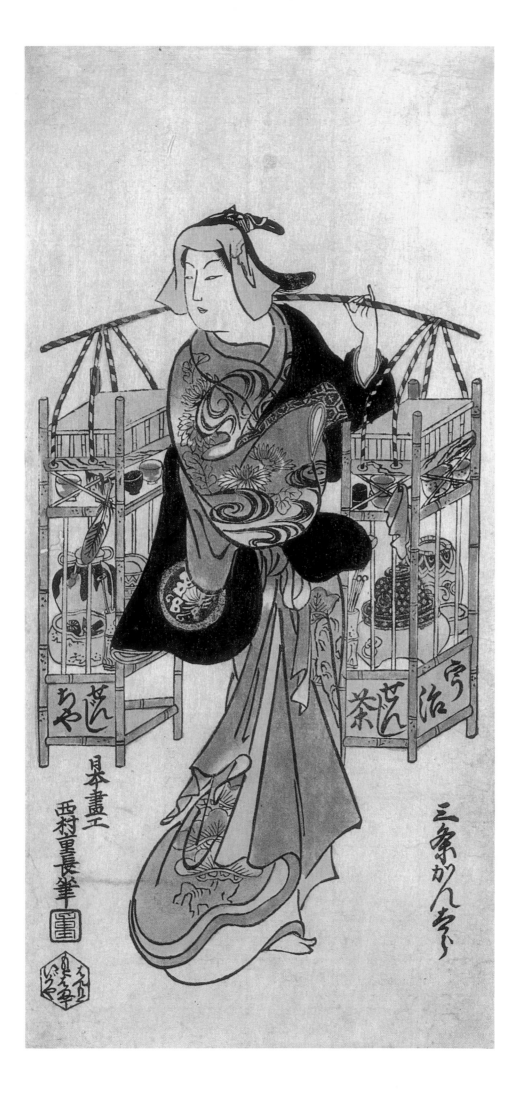

10a

TORII KIYOSHIGE

The Actor Matsumoto Koshiro in Character

Sumizuri-e with hand-colouring. 64.8 x 15 cm. c.1742. The Art Institute of Chicago

Torii Kiyoshige (active c.1728-60) produced some powerful actor prints in ink outline, alone or with boldly decorative hand-colouring. He is thought to be a late pupil of Kiyonobu I, but is distinguishable from the generality of Torii masters by the persistently malevolent expression of his actors, conveyed in lines of awkward angularity.

10b

NISHIMURA SHIGENAGA

Sanogawa Ichimatsu, as Hisamatsu in a Play Performed in 1743

Lacquer-print, hand-coloured, 65.4 x 15.2 cm. The Art Institute of Chicago

Certain Kabuki actors, like pop-stars everywhere today, achieved an astonishing popularity, and none more so than Sanogawa Ichimatsu, portrayed in this print, who was a rave for a decade, and the subject of innumerable colour-prints. He was immediately recognizable by the particular check pattern of his *kimono*, which became known as the Ichimatsu pattern.

Yamamoto Yoshinobu was one of a number of obscure artists who produced prints during the period of the two-colour prints.

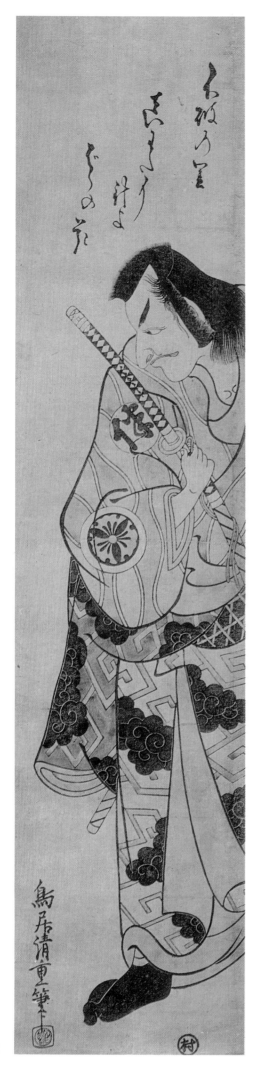

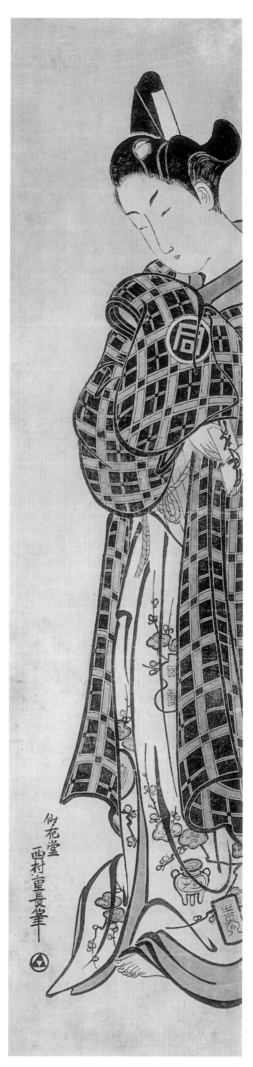

a

b

Actors as Lovers under one Umbrella, in a Play Performed in 1747

Benizuri-e. 43 x 28.5 cm. Hawaii, Honolulu Academy of Arts, Michener Collection

Until recently, it was accepted that Ishikawa Toyonobu (1711-85) began his career as a pupil of Shigenaga under the name of Nishimura Shigenobu, issuing his first hand-coloured prints under that name, and soon after 1737 changing his name to Toyonobu, but, on the grounds of incompatible styles, doubts are now being raised about this relationship. Toyonobu's prints are among the finest of the primitives, though as applied to him the term has already lost much of its significance. True, among his earlier prints, the splendid *kakemono-e* show a debt to Masanobu, but with the coming of the *benizuri-e*, the poetry in the Edo air was instilled into his prints, and some Japanese critics, Noguchi for instance, who calls him the 'lyric poet of Ukiyo-e', look upon his work as one of the high-water marks of the whole colour-print movement. He continued working into the era of full polychrome printing, but by that time was overshadowed by Harunobu.

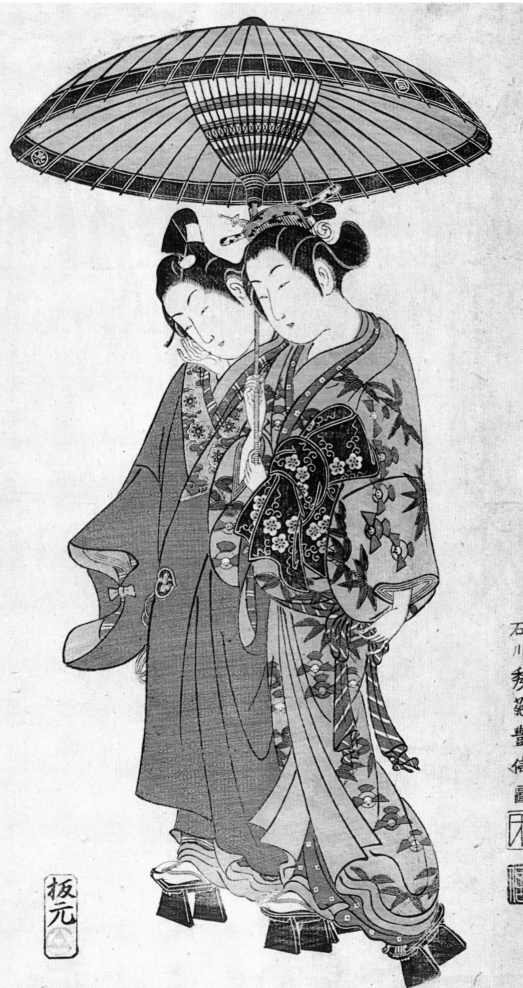

Boy Dancing with a Hobby-Horse

Benizuri-e. 43.2 x 30.5 cm. c.1755. London, British Museum

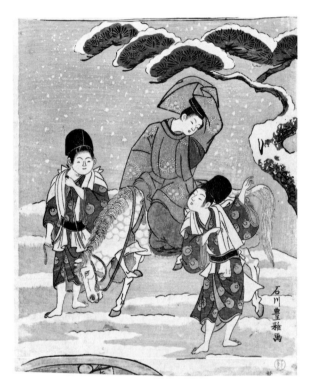

The boy is dancing with a hobby-horse against an artificially contrived background of chrysanthemums. At his feet, to complete the arabesque, are a drum and stick, and a windmill. The verse reads 'The morning mist of spring disperses as the sound of the drum is heard.'

Ishikawa Toyomasa (active c.1767-73) was a pupil of Toyonobu. In Fig. 13 the three boys in the snow are parodying the classical subject 'Crossing the Sano', normally symbolized by a nobleman at a river-crossing, shielding his head with a raised sleeve.

Fig. 13
Ishikawa
Toyomasa: Three
Boys in the Snow

27.9 x 20.3 cm. Private
Collection

TORII KIYOHIRO

Children Spinning Tops

Benizuri-e. 43.2 x 30.2 cm. c.1745. London, British Museum

Torii Kiyohiro (active 1737-68) was a pupil of Kiyomasu II. Like most members of the Torii family he was mainly a designer of theatrical prints and he was at his best in the two-coloured, *benizuri*, form. He has a piquancy of line and motif that singles him out from his fellow Torii artists, who were inclined to be, if anything, a trifle conservative.

In Plate 13 the children spinning tops are watched by a young man behind them. Under his left arm he carries a sword from which dangles a bunch of love letters. The verse reads 'The elder and the younger brother dance their spinning-top dance, like butterfly and plover.'

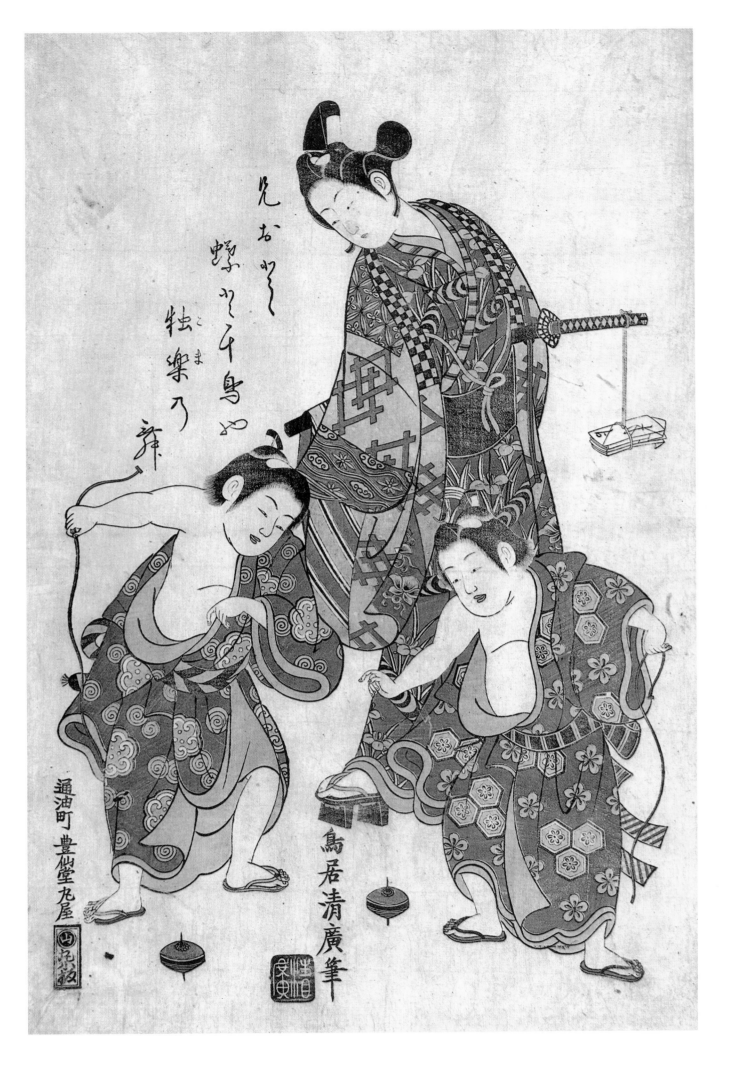

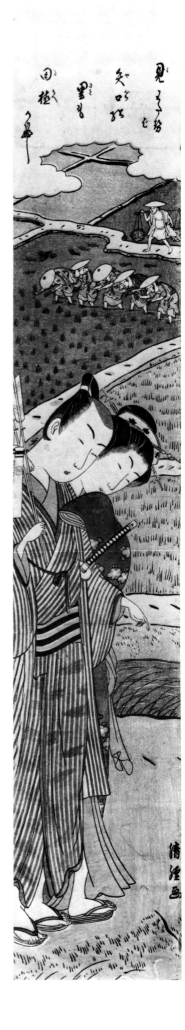

TORII KIYOMITSU

The Actor Segawa Kikunojo II as a Girl Komuso

Three-colour block. 31.1 x 14 cm. c.1762-3. Private Collection

Torii Kiyomitsu (1735-85) was a son and pupil of Kiyomasu II. He was one of the most prominent artists of the period 1750-65, and one of the first to experiment with three- and four-block printing and the colours obtainable from over-printings. His prints in the narrow upright format *(hoso-ban)* may be somewhat monotonous in the repetition of certain mannerisms, but his pillar-prints are superb and include a number in which the nude or half-draped figure is depicted with a grace and naïveté that is as delightful as it is surprising.

A komuso is a strolling flute-plater or a begging priest.

A pupil of Kiyomitsu, Torii Kiyotsune (active 1757-c.75) worked much in his master's manner, though without his assurance. His later prints show also the influence of Buncho and Harunobu (Fig. 14).

Fig. 14
Torii Kiyotsune:
An Actor Walking
with a Young
Woman in the
Ricefields at the
Time of the Spring
Transplanting

Pillar-print. c.1774. Private
Collection

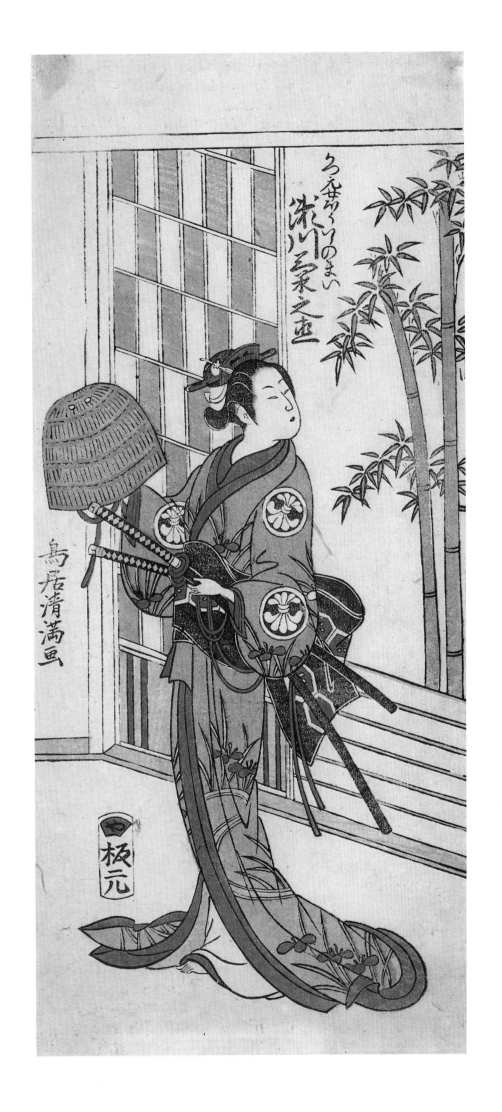

'The Evening Bell of the Clock'

One of a series of 'eight parlour scenes'. 28.6 x 21.6 cm. c.1766.
The Art Institute of Chicago

Fig. 15
Nishikawa
Sukenobu: Woman
and Maid-servant
(left); Mother and
Child (right)

Two pages from the
picture-book 'Ehon
Asakayama', 1739.
Sumizuri-e. 25.4 x 19 cm.
Private Collection

Little is known of the early years of Suzuki Harunobu (d.1770). A con-
temporary has left it on record that Harunobu was over forty when he
died. Shigenaga is said to have been his master, but he was more obvi-
ously influenced by the Kyoto artist Nishikawa Sukenobu (1674-1754).
Sukenobu's immense output, aside from paintings, was confined to illus-
trated books and albums, notable for their portrayal of women of a gentle
winningness new to Ukiyo-e, in a style contrasting with the primitive
strength of Moronobu, Kiyonobu and Kaigetsudo (Fig. 15). Harunobu
designed a few two-colour prints before the introduction of the full
colour-print (*nishiki-e*, 'brocade-print'). With the enhanced possibilites of
the new technique, from 1765 came an astonishing advance in his pow-
ers. He exemplifies one side of the colour-print's charm – the depiction
of a world of diminutive graceful creatures, an idyllic world where work is
never taken seriously and play is the real business of life.

Plate 15 is one of a series of 'Eight Parlour Scenes' which translate the
classical 'Eight Views' into everyday events in and about the house.

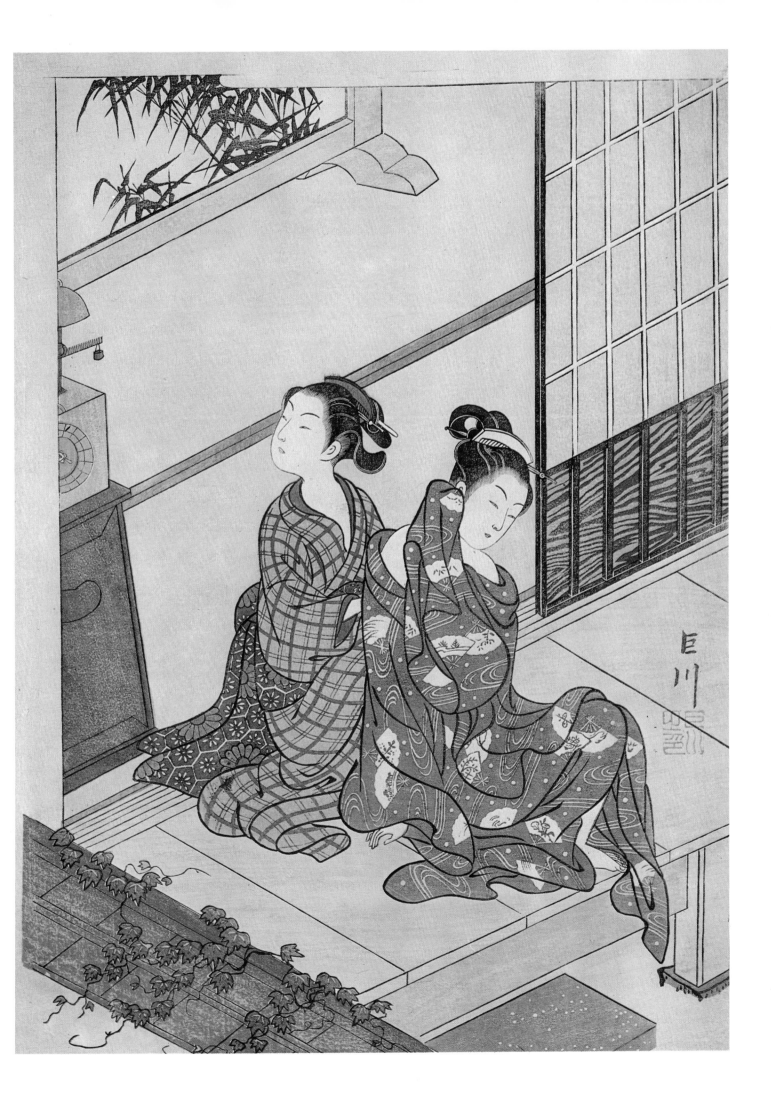

Girl Performing the 'Lion Dance'

38.4 x 26.4 cm. c.1769-70. Mannedorf, Switzerland, Amstutz Collection

In the period from 1765, the first year in which *nishiki-e* were published on any scale, until his death in 1770, Suzuki Harunobu designed a considerable number of prints, but it is likely that many signed with his name, or unsigned and ascribed to him, are the work of talented pupils or followers. Among them are Harutsugu, Komai Yoshinobu, Komatsuken, Masunobu, Kuninobu and Fujinobu, but the best known is Harushige. Harushige was an art-name of Shiba Kokan, who in his memoirs recorded that he had forged Harunobu's signature on his own prints after Harunobu's death in 1770 (Fig. 16).

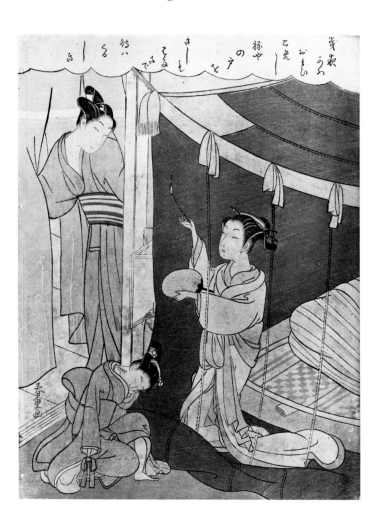

Fig. 16
**Harushige:
Courtesan Leading
a Youth to her Bed
with a Lighted
Taper whilst her
Young Attendant
Sleeps**

27.3 x 12.4 cm. London,
British Museum

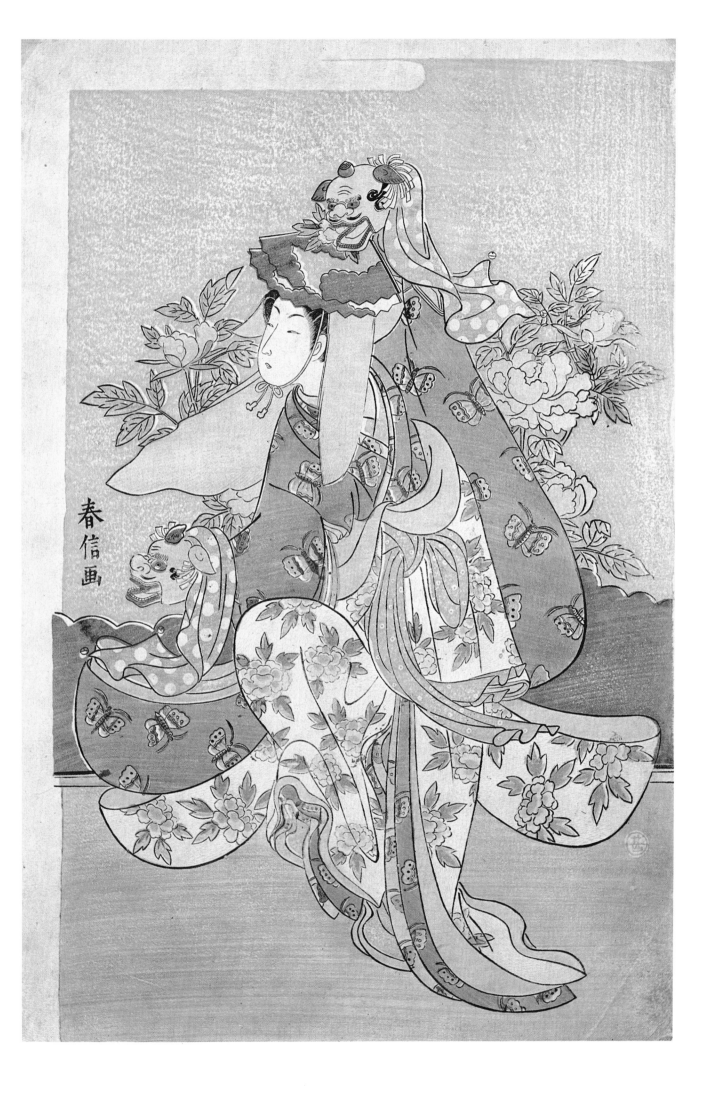

17a

SUZUKI HARUNOBU

The Assignation: Two Lovers at a Gate

Pillar-print. (Hashira-e). 70.8 x 12.1 cm. c.1768. Private Collection

17b

ISODA KORYUSAI

At the Gate

Pillar-print. 70.8 x 12.4 cm. c.1771. The Art Institute of Chicago

Harunobu and Koryusai each made a virtue of the necessity imposed by the narrowness of the pillar-print, and both showed the utmost ingenuity and resourcefulness in handling one or more figures within a space that left little room for manoeuvrability (Fig. 17). In 'The Assignation' for instance (Plate 17a), Harunobu cut into both figures with the vertical edges of the print and presents a kind of stolen 'crack-in-the-door' view of the lovers; in 'At the Gate' (Plate 17b) Koryusai places the figures one above the other, emphasizing the height with the uprights of the timber framework of the gate and house.

Fig. 17
Isoda Koryusai:
Girls Washing
Clothes
at a Well

68 x 11 cm. Private
Collection

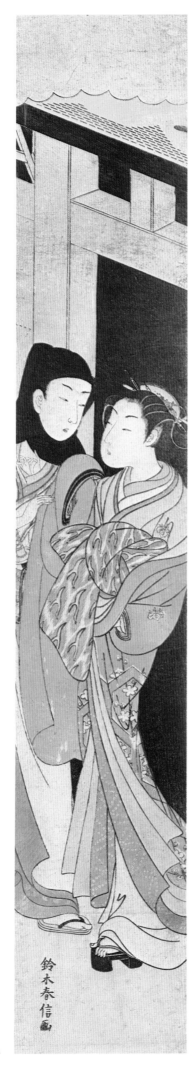

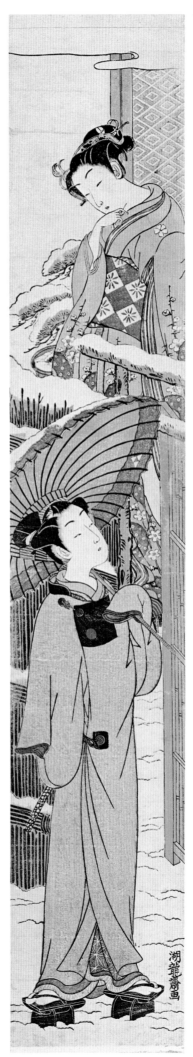

a

b

The Courtesan Morokoshi of Echizen-ya with her Child, and an Attendant Standing by

From the series 'New Patterns for Young Leaves'. 38.7 x 25.4 cm. c. 1776-7.
London, British Museum

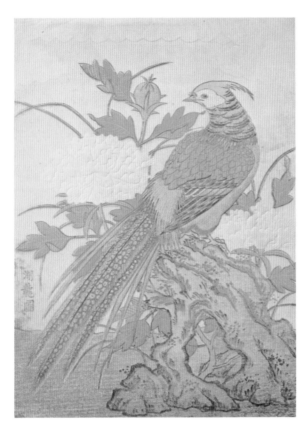

Isoda Koryusai (active c.1763-85) came of *samurai* stock, but forsook the service of a nobleman to study Ukiyo-e painting. His first master may have been Shigenaga, but he acknowledged his debt to Harunobu in an inscription on a print, and there is no doubt that it is Harunobu's influence which is paramount in his early prints. But Koryusai was far more than an imitator: his *kacho-e* are of supremely fine design (Fig. 18), his *hashira-e* generally held to show the inventive composition of the Japanese artist at its best, and his great series of fashion-plates, 'New Patterns for Young Leaves' (a euphemism like Proust's '*les filles en fleur*') designed with large-scale figures that show a reaction from the diminutive creatures of Harunobu's world, inaugurated the use of the large upright sheet which thereafter was in almost universal use by the designers of *bijin-ga* (pictures of beauties). After 1785, he devoted himself almost exclusively to painting.

Fig. 18
Isoda Koryusai:
'Golden Pheasant
and Peonies'

c.1769-70. Lausanne,
Reise Collection

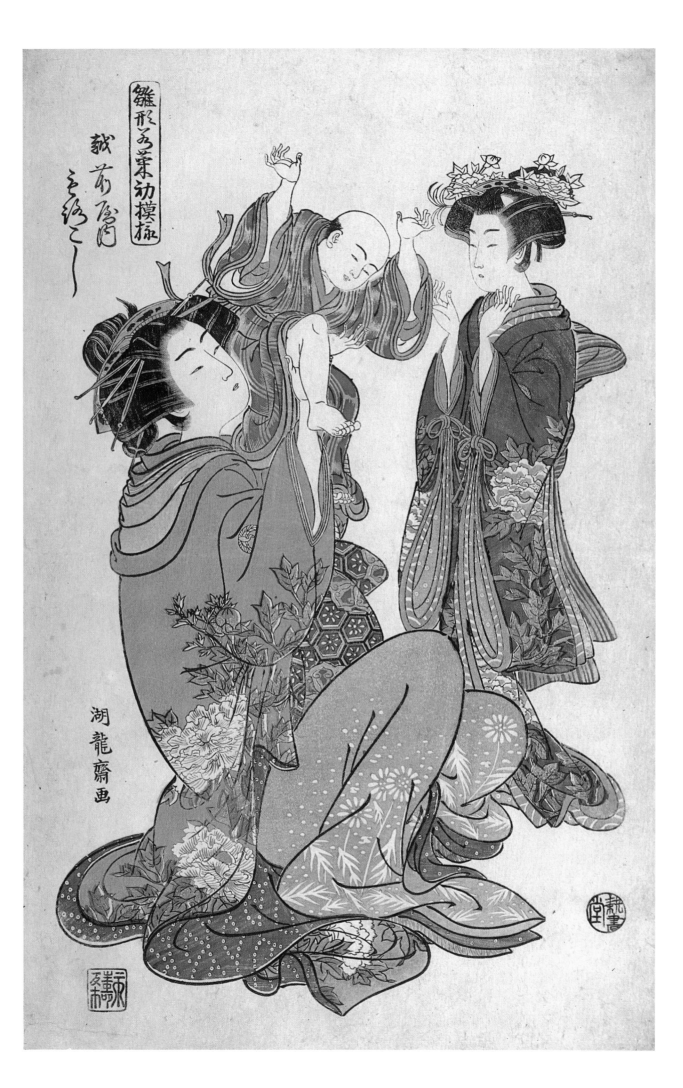

KATSUKAWA SHUNSHO

The Actors Ichikawa Danjuro IV and Nakamura Utaemon in a Theatrical Duo

26.4 x 19.1 cm. 1769. Munster, Scheiwe Collection

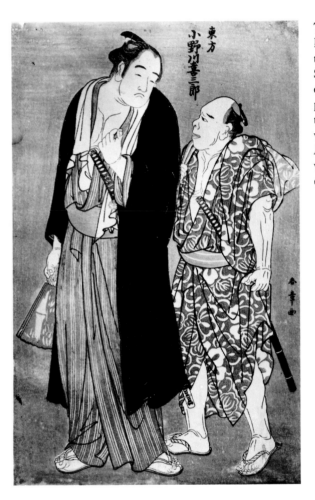

Trained in a sub-school of Ukiyo-e that confined its activities to painting, Katsukawa Shunsho (1726-92) began with prints that owe something to the all-pervading influence of Harunobu. But although collaborating with Shigemasa in the book mentioned in the note to Plate 22 and in a series of prints dealing with sericulture, he found his true vein in the theatrical print at a time when the Torii family no longer completely dominated the scene. His countless actor prints in the *hoso-ban* format are composed with a rare restraint of colour and design and succeed in bringing the *Kabuki* stage to life before our eyes. But they are only one side of his work: he is equally great in all the other spheres of the colour-print designer (Fig. 19), and one of the school's most accomplished painters.

Fig. 19
Katsukawa
Shunsho: The
Sumo Wrestler,
Champion of the
East, Onogawa
Kichisaburo,
Walking with his
Attendant

38.1 x 25.4 cm. Mid-1780s.
Private Collection

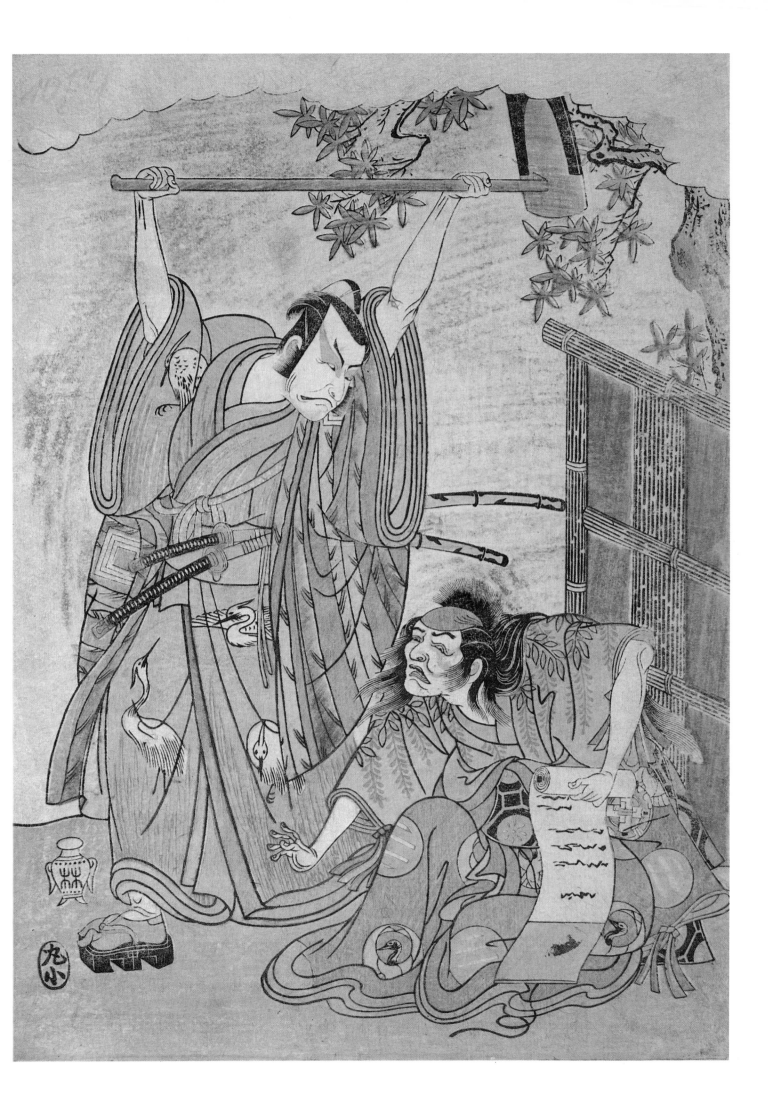

20

KATSUKAWA SHUNSHO

The Actor Otani Hiroemon IV as a Highwayman in a Play Performed in 1777

30.8 x 14 cm. Minneapolis Institute of Arts

Otani Hiroemon IV is swinging the kind of dark lantern that, in *Kabuki*, immediately identifies him as a robber; the low-key colour-scheme, with black predominating, is another means by which Shunsho conveys the evilness of the character. Writing of this print, a former owner, Louis Ledoux, suggested that 'the genius of Shunsho was stimulated to its finest productions when the problem before the artist was to depict one of those tense moments of the *Kabuki* stage when violent mental action is co-ordinated with readiness for violent physical action.'

Fig. 20
Katsukawa
Shunsho: The
Actor Nakamura
Nakazo I in
Character

Pillar-print.
67.3 x 12.1 cm.
Private Collection

The Actor Segawa Kikunojo II as O'hatsu in a Play Performed in 1767

27.3 x 12.4 cm. London, British Museum

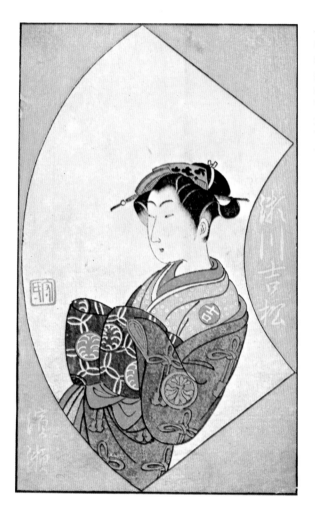

Another artist of the *samurai* class, Ippitsusai Buncho (active c.1765-c.75) seceded from the Kano school and devoted himself, like Shunsho, to the stage. His actor-prints stand apart from all others in their extreme elegance of drawing and a disquieting emotional quality that affects us like a poignant discord in music. In 1770 he collaborated with Shunsho in the 'Book of Stage Fans', a collection of portraits of actors in fan-shaped frames, one of the finest of the earlier *ehon* (Fig. 21). Like so many other Ukiyo-e artists – Toyonobu, Shunman, Kitao Masanobu are a few – he was a poet of some standing.

Fig. 21
Ippitsusai Buncho:
The Actor Segawa
Kichimatsu

From Ehon Butai Ogi.
1770. 24.8 x 15.9 cm.
Private Collection

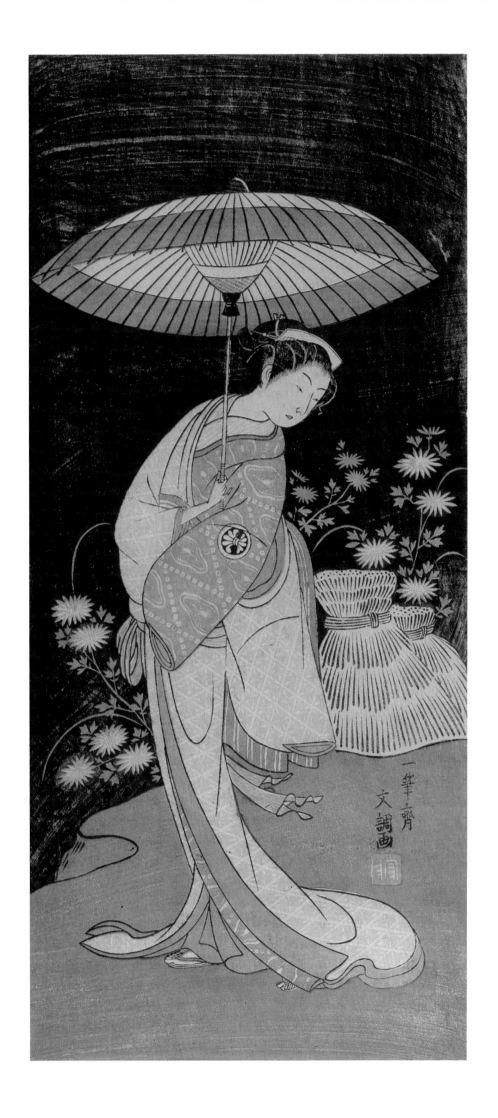

Rehearsing a New Song

Unsigned. 37.8 x 25.4 cm. c.1777. London, British Museum

Fig. 22
Kitao Shigemasa: A
Music Concert by
the Courtesans of
Tama-ya

From the 'Mirror of Fair
Women of the Green-
Houses'.
1776. 27.9 x 36.2 cm.
Private Collection

After Harunobu's death, and before Kiyonaga made himself felt, Kitao
Shigemasa (1739-1819) was perhaps the most commanding figure in
Ukiyo-e. Prints of such series as 'Beauties of the East', often unsigned,
show, like Koryusai's, a reaction from the *petite* of Harunobu. The figures
have an amplitude and a naturalism that make these designs among the
most memorable of the period. Before this, probably a fellow pupil of
Harunobu's in Shigenaga's studio, he drew in the Harunobu manner, and
collaborated with Shunsho in one of the loveliest of all the colour-printed
picture-books, the 'Mirror of Fair Women of the Green-Houses' of 1776
(Fig. 22); and after Kiyonaga's ascendancy, devoted himself largely to
book-illustration, his separate-sheet prints being uncommon. His long
life carried him into the nineteenth century, and he was still producing
work of a high quality almost to the end.

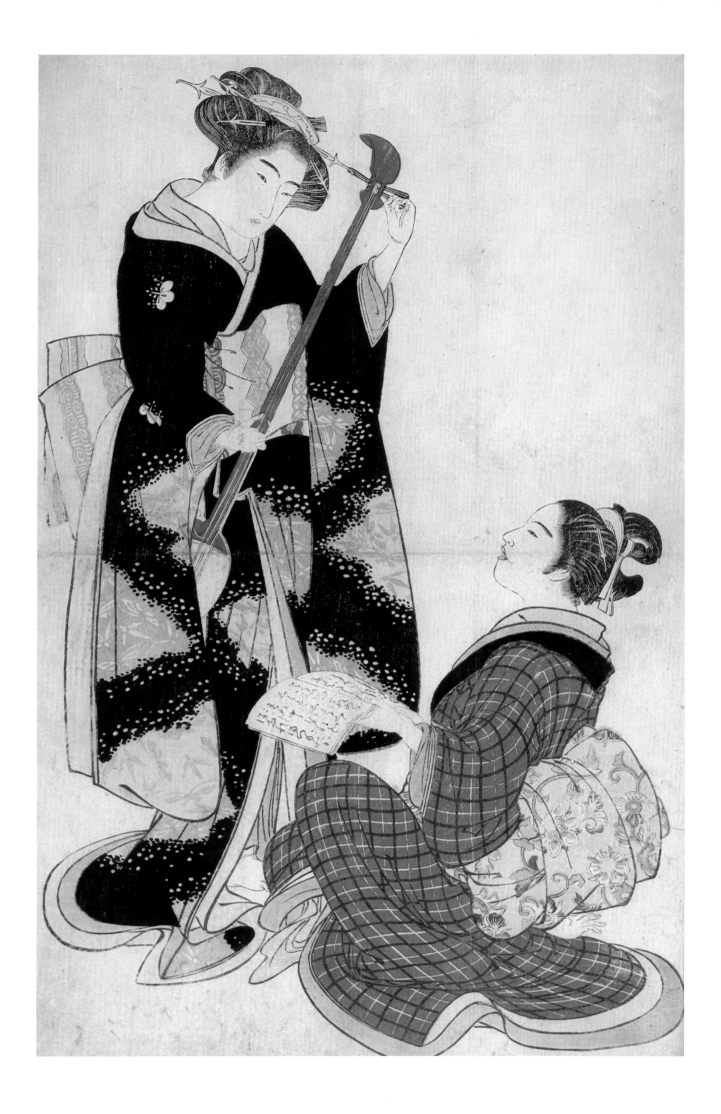

TORII KIYONAGA

A Lady with two Servants

One of the set 'Fashions in the Brocade of the East'. 38.1 x 25.4 cm. 1783.
Boston, Museum of Fine Arts, Bigelow Collection

Torii Kiyonaga (1752-1815) came to Edo when a young man as a follower
of the trade of tobacconist and bookseller. He was adopted into the Torii
family, and became the pupil of Kiyomitsu. His early work up to about
1780 follows the Torii actor-print style and there are lingering traces of
Harunobu and Koryusai; but with the eighties, Kiyonaga seemed sud-
denly to find his feet, and he produced series after series of prints that
are among the classics of Ukiyo-e art. The most famous are called
'Fashions in Brocade of the East' (Plate 23) and twelve diptychs entitled
'Twelve Months in the South'. These, and similar prints of the Edo
round of pleasure, with an increasing emphasis on the open air, the atmo-
sphere and scenery of the town and its purlieus, are characterized at their
culminating point by immensely tall figures of regal proportions, welded
into monumental designs, often processional, like a frieze; drawn with a
mastery that few Ukiyo-e artists rival. As the decade waned, the figures
returned to more normal height and there is something generally less
imposing about the later prints, as if the fires of genius had been damped
down. His influence on his contemporaries was enormous, comparable to
Harunobu's over *his* generation, every designer of note falling under his
spell to a greater or lesser degree. Soon after 1790 he seems to have given
up print-designing and returned to his shopkeeping.

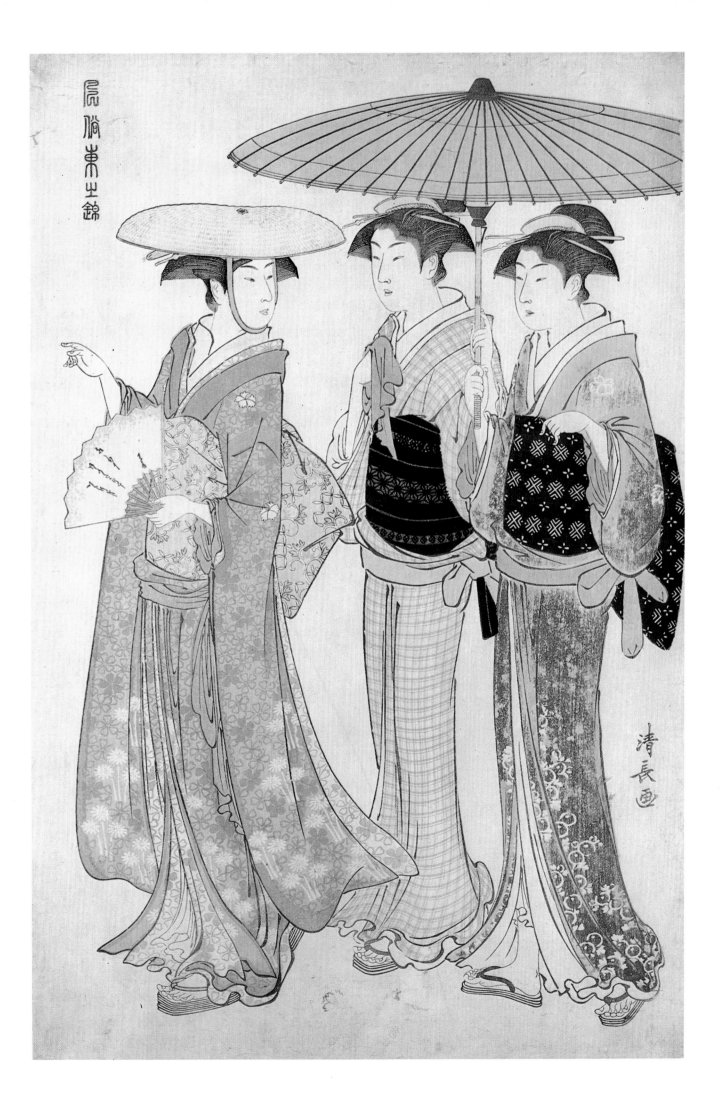

Cherry-Blossom at Asakayama near Edo

Centre sheet of a triptych. 37.5 x 24.1 cm. c.1787. London, British Museum

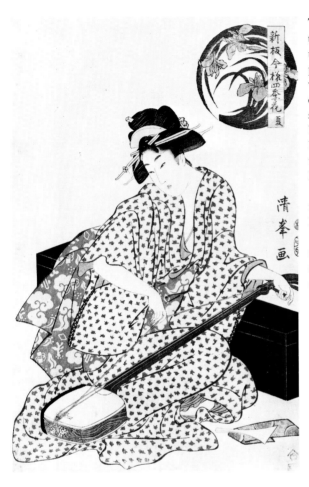

The triptych, and other polyptych formats, were distant echoes of one of the earliest traditional formats for paintings – the *makimono*, the laterally unwinding scroll. And just as the *makimono*, when presenting a continuous panorama, was opened to display only a section at a time, so the triptych was usually so designed that each sheet formed a perfectly satisfactory composition even when divorced from its companion sheets. The present sheet is a case in point. The print was made on three separate blocks because it would have been difficult or unwise to use a single large block, but the designer took advantage of this practical necessity by ensuring that he created three separate prints that together composed an harmonious entity.

Kiyonaga's pupils include Kiyohisa and Kiyomasa, but his closest followers are Shuncho, Shunzan and Shunman, mentioned below, and Banki, Banri, Ryu-unsai and Enshi.

Torii Kiyomine (1787-1869) was one of the last of the great line of Torii artists, and worthily upheld the traditions so rapidly being forsaken by his contemporaries. His prints of courtesans are often of surprisingly high quality considering their late date (Fig. 23).

Fig. 23
Torii Kiyomine: A
Geisha Restringing
her *Samisen*

From a series 'Newly-
printed: Flowers for a
Modern Four Seasons'.
Seal-dated 1807.
38.7 x 25.4 cm.
Private Collection

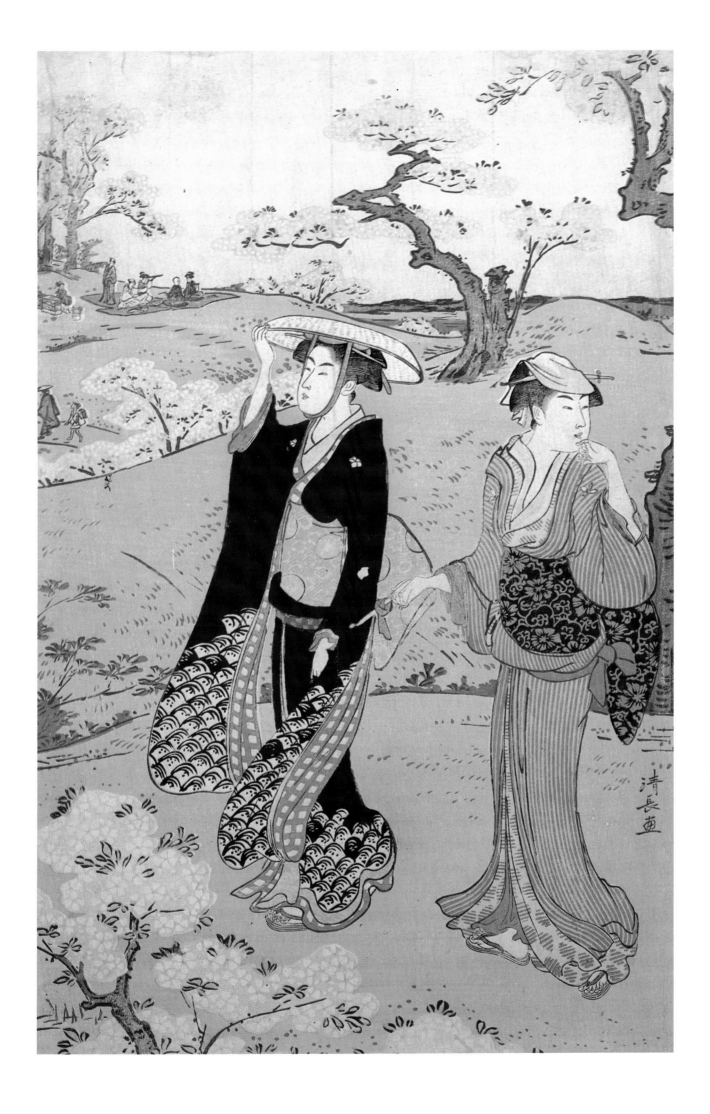

The Battle of Yashima, Dan-no-ura, an Event in the Civil War between the Minamoto and Taira Clans

Uki-e print. 24.1 x 37.5 cm. c.1775-80. London, British Museum

The first prints of Utagawa Toyoharu (1733-1814) were designed whilst Harunobu's influence was still current, and his pillar-prints and small-size prints of this period are full of the poetry of the time. Later, he developed the *uki-e* type of perspective picture which combines European and Japanese elements in an intriguing manner. He is the founder of the Utagawa line of artists; Toyokuni and Toyohiro were his major pupils.

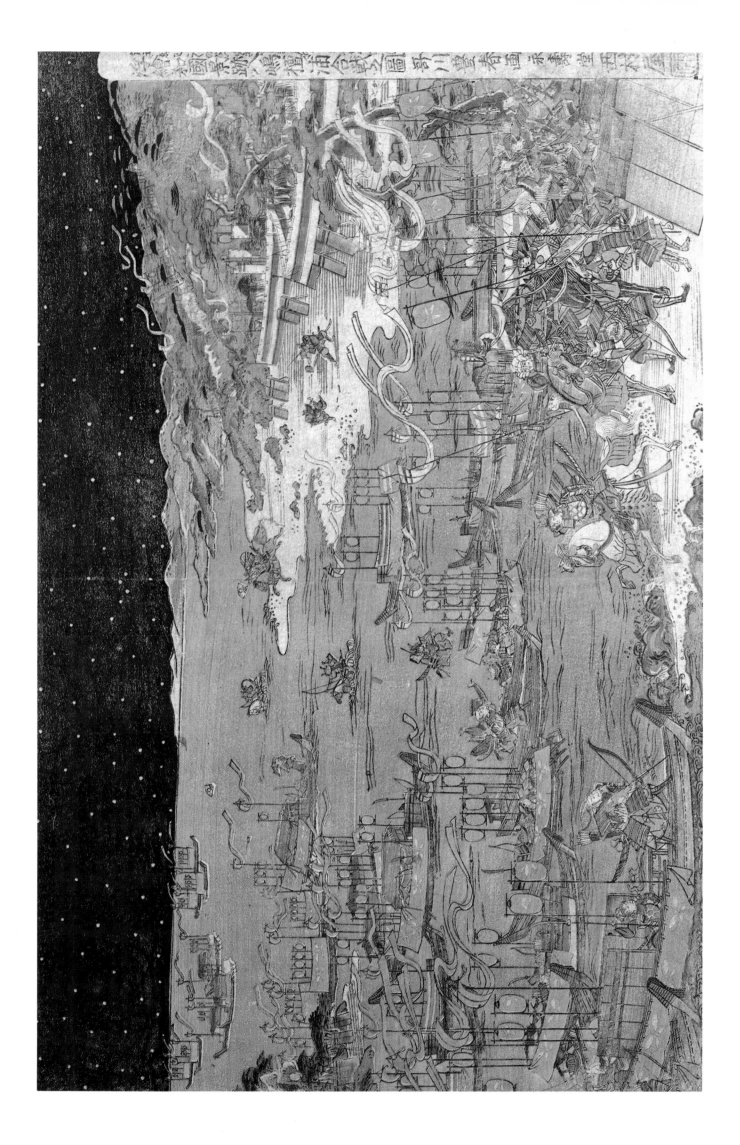

KITAO MASANOBU

The Courtesans Hitomoto and Tagosode

Diptych from the album 'The Autographs of Yoshiwara Beauties'. 37.5 x 50.2 cm. 1783. London, British Museum

Fig. 24
Keisai Masayoshi:
Simplified Forms
of Birds and
Animals

Pages from the picture-book 'Birds and Animals in Simplified Forms'.
1797. 26.7 x 35.6 cm.
Venthone, Switzerland,
Nathan Chaikan
Collection

Kitao Masanobu (1761-1816) was a pupil of Shigemasa of uncommon precocity. He matched his master's finest designs whilst still in his early twenties, designed seven large-scale prints for an album 'The Autographs of Yoshiwara Beauties' (1783) that are among the most splendid creations of the colour-print art and technique, and then, when the leadership of the school seemed within his powers, forsook print-designing for writing, and under the name of Santo Kyoden produced novels that are among the comic classics of Japanese literature. A true Edokko, an Edo 'Cockney', he typifies the new class of commoner, with a gusto for the 'fast life', for novelty, for the beauty of the 'passing world.'

Another pupil of Shigemasa's was Keisai Masayoshi (1761-1824). After some promising prints in the Ukiyo-e style, he forsook the school and is chiefly remembered for book-illustrations of great individuality consisting of summary sketches of genuine verve (Fig. 24).

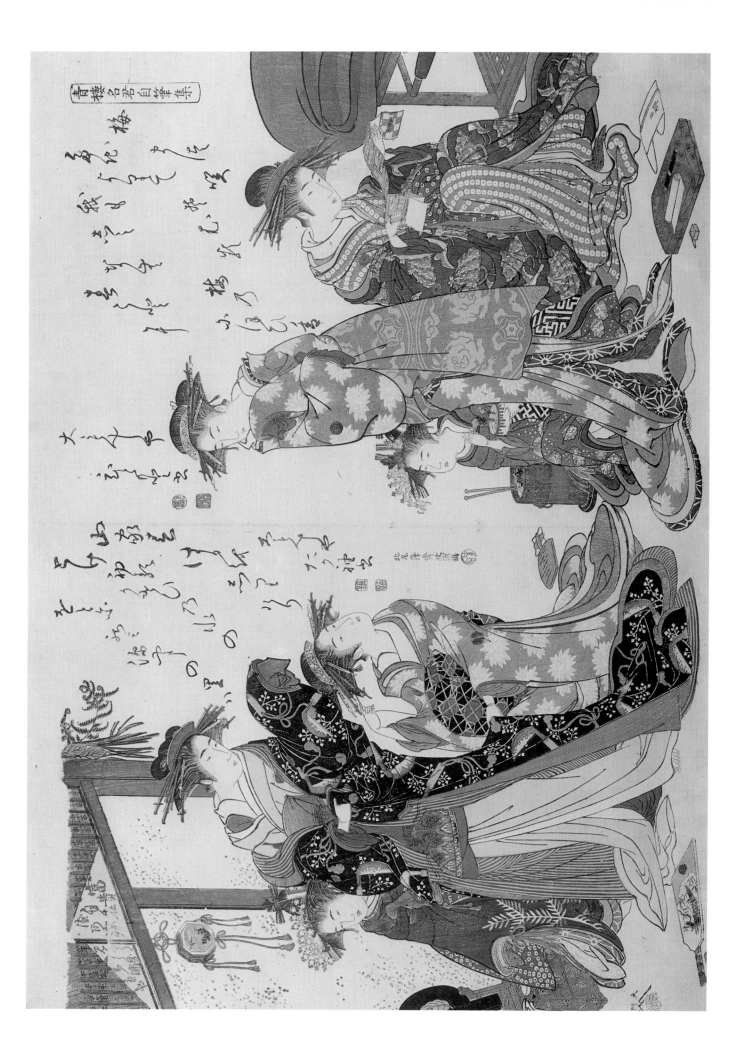

The Toi, one of the 'Six Jewel Rivers'

Part of a six-sheet composition. 36.8 x 24.8 cm. c.1787. London, British Museum

Fig. 25
Kubo Shunman:
Hawk-Moth and
Butterflies

From a series 'Pictorial
Record of a Swarm of
Butterflies'. 20 x 18.1 cm.
Private Collection

Kubo Shunman (1757-1820), after an initial training under obscure painters, studied Ukiyo-e with Shigemasa, but soon succumbed to the vogue-setting Kiyonaga. But unlike Shuncho, he retained his own identity, attaining a degree of refinement in everything he did which places his relatively small output in a category of its own. He was an experimenter in colour, using silvery greys and light touches of soft colours with exquisite results (his most famous work, the six-sheet print of the 'Six Jewel Rivers', is a perfect example; Plate 27); and excelled in *surimono* (Fig. 25), and in the illustration of books of poetry. He himself was a noted poetry-master and his poetry seems to have overflowed into his designing.

Fig. 25 was made for a poetry club 'The Society of the Mist'.

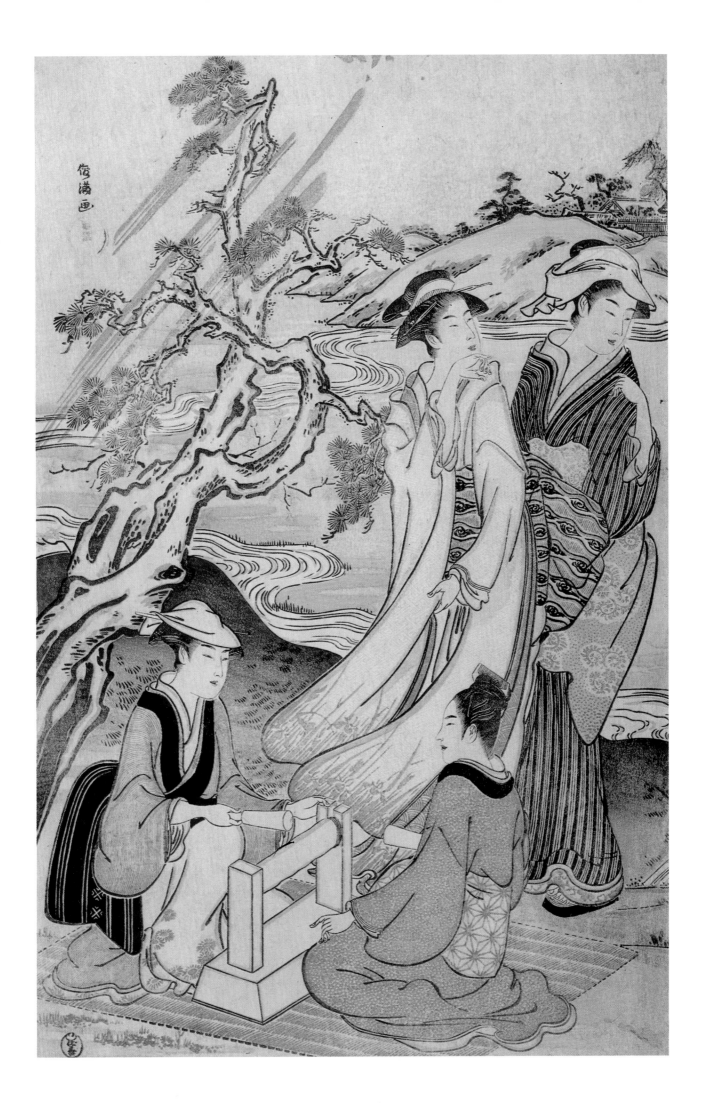

Head of an Onnagata

38.1 x 25.4 cm. c.1787-8. Mannedorf, Switzerland, Amstutz Collection

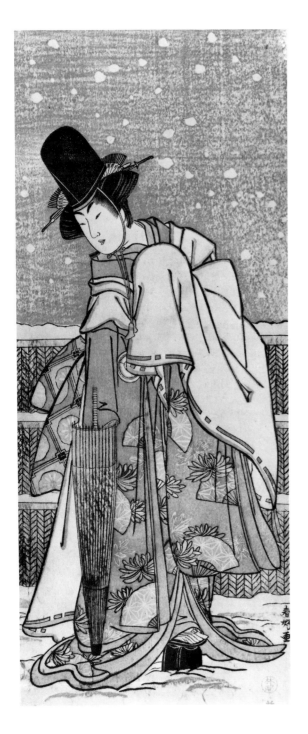

Katsukawa Shunko (d.1827) was a close follower of his master Shunsho. His actor prints in the *hoso-ban* format (Fig. 26) have the same admirable qualities as, and but for the signature would be difficult to distinguish from, his master's. Paralysis attacked him in middle age and prevented him from realizing his early promise. He was one of the earliest to design *O-kubi-e*, 'Large Heads', and they are of uncommon power and originality.

 An *onnagata* is a male actor taking female parts.

Fig. 26
Katsukawa
Shunko: The Actor
Iwai Hanshiro IV
in a Feminine Role

31.1 x 14.3 cm. Private
Collection

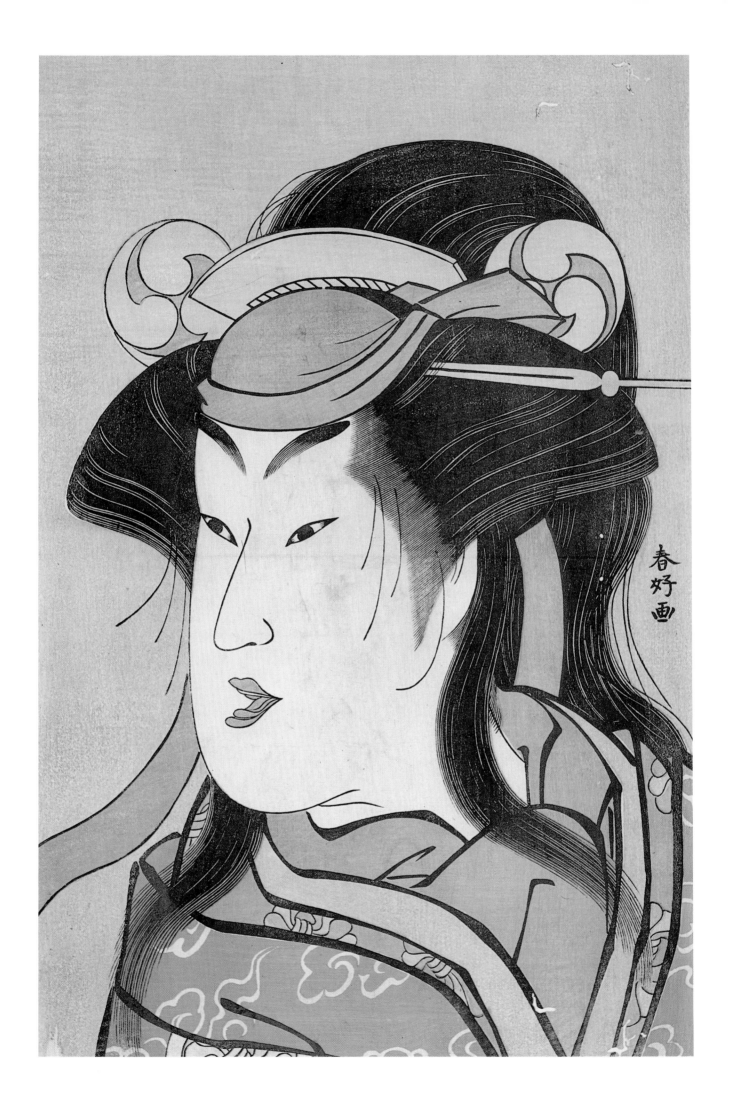

The Wrestler Onogawa and the Tea-House Waitress O'hisa

38.7 x 25.4 cm. c.1792. London, British Museum

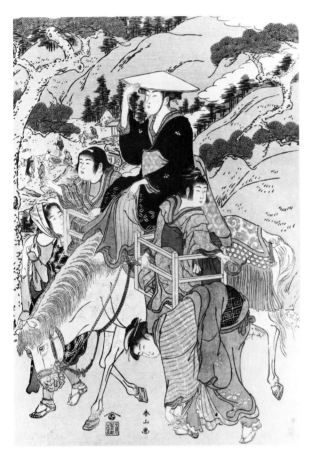

Fig. 27
Shunzan: A Party
of Women on a
Pilgrimage to Ise

The centre sheet of a trip-
tych. 34.9 x 25.4 cm.
Private Collection

Apart from the fact that Yushido Shuncho (active c.1780-1800) was a pupil of Shunsho, nothing is known of his life. His personality is almost completely overshadowed by that of Kiyonaga, whose style, after breaking with Shunsho, he followed with complete fidelity. In his pillar-prints it is possible to detect an individual note but generally he is like a milder version of Kiyonaga.

Shunzan (active 1780-1800) was another apostate from Shunsho's academy to Kiyonaga's, but his history is obscure. Fine prints exist from the period of his tutelage under Shunsho and Shunei, but his best work was done in direct emulation of Kiyonaga whose style he cleverly assimilated (Fig. 27).

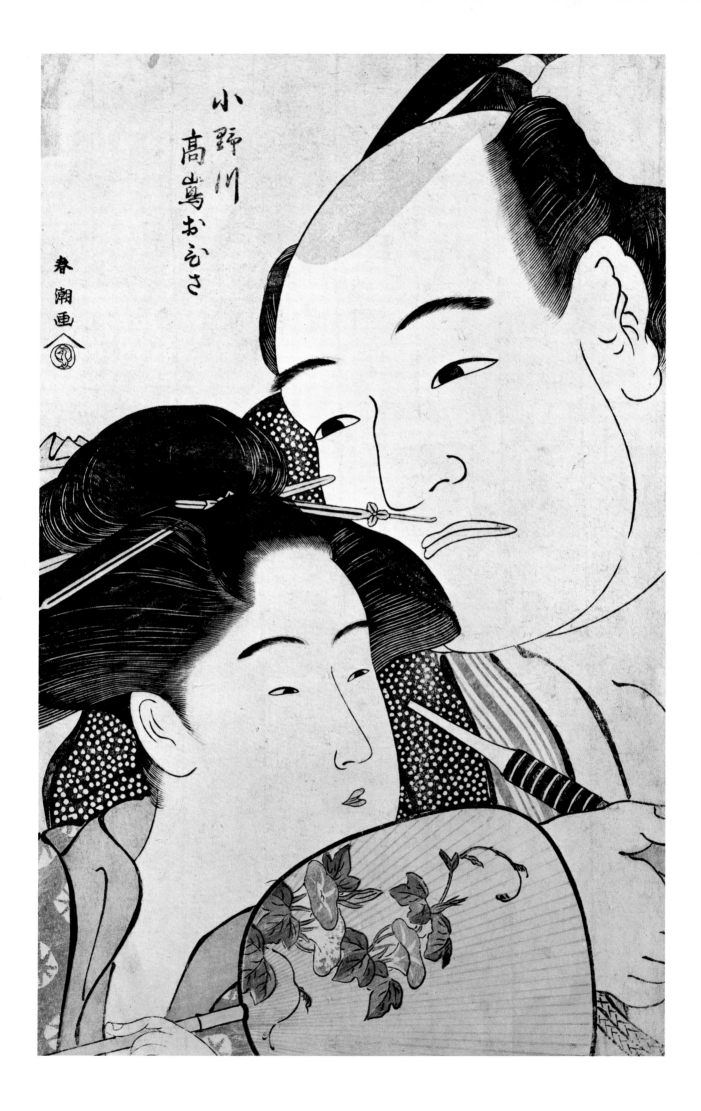

'The Passionate Type'

From the 'Ten learned studies of Women', on Mica-ground. 38.1 x 25.4 cm. c.1792-3.
London, British Museum

Fig. 28
Kitagawa Utamaro:
'A Cherry-
Blossom-Viewing
Party'

From 'The Image of
Fugen'. 1790

When Kiyonaga retired, Kitagawa Utamaro (1753-1806) was ready to
assume the leadership of Ukiyo-e. Of practically the same age as
Kiyonaga, Utamaro was slower to develop and had a different training,
partly in the Kano school, partly under Toriyama Sekien, who was not a
true Ukiyo-e artist. Influenced first by Shigemasa and Kitao Masanobu,
and then by Kiyonaga, Utamaro was never a copyist, but showed individ-
uality from the start. In 1788, his 'Insect Book', a wonderful set of prints
of flowers and insects and reptiles, was published, and it was followed by
other albums of great charm which include a few landscapes (Fig. 28).
His mature powers, however, were devoted to the women of the
Yoshiwara, and his prolific output in the nineties contains prints that are
among the masterpieces of the colour woodcut. With the turn of the cen-
tury, his art, infected by the spirit of the age and the need to satisfy
exploiting publishers, deteriorated. Some prints of this late period issued
under his name are the work of pupils or forgers. He died in 1806 not
long after an imprisonment for an infringement of the censorship laws
had finally broken a constitution already impaired, so tradition declares,
by dissipation. Pupils and followers include Utamaro II who used the
same signature as his master; Shikimaro, Kikumaro (also called
Tsukimaro), Hidemaro, Bunro, Banki II, Hisanobu, and Ryukoku.

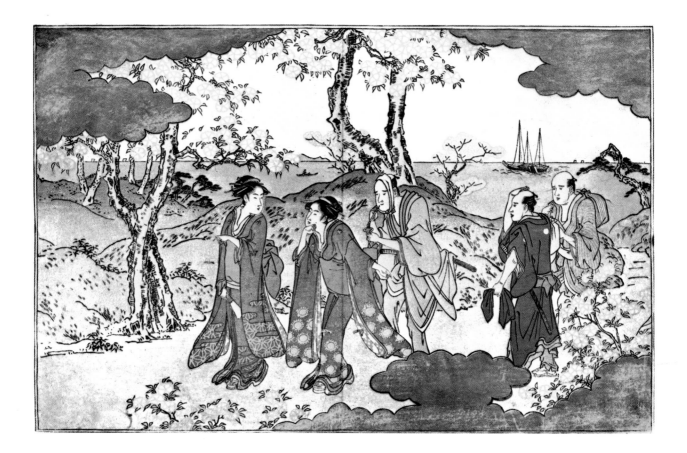

KITAGAWA UTAMARO

The Lovers Hambei and O'chie

From a series 'An Array of Passionate Lovers'. 35.9 x 24.1 cm. 1797-8.
London British Museum

In the late 1790s, Utamaro designed several series of prints, all with rather enigmatic titles, portraying lovers who were the heroes and heroines of well known *joruri*. Originally written for puppet performances, *joruri* were also chanted with *samisen* accompaniment, and often taken over by Kabuki playwrights. Whatever the background stories may have been, and they mostly concern illicit or tragic love affairs, Utamaro used the protagonists simply as twin half-length figures in compositions that are among the most impressive to us in this 'Golden Decade' of the 1790s.

Sekijo and Sekiho were also the pupils of Sekien but worked much under the influence of Utamaro.

The prints of Kikgawa Eizan (1787-1867) are confined to *bijin-ga* based on the later work of Utamaro, not a good model. Though successful in their day they rarely strike us as other than rather feeble imitations of the master.

Harukawa Goshichi (worked first half of the nineteenth century) was mainly a *surimono* designer.

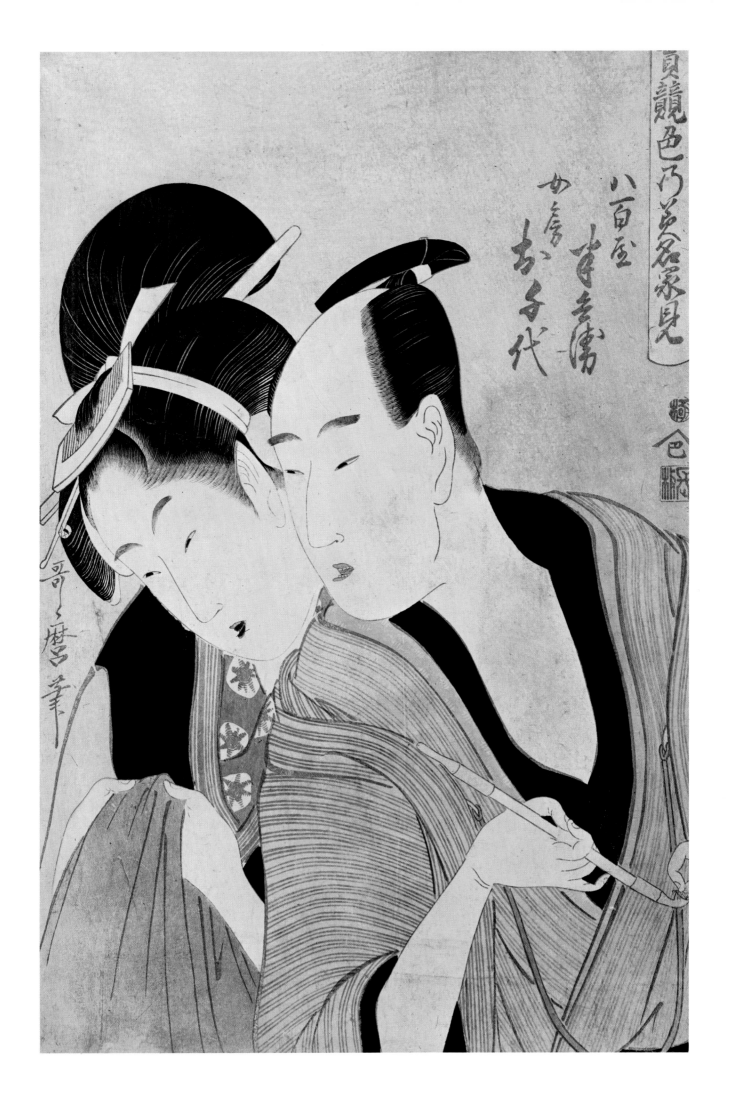

KITAGAWA UTAMARO

The Courtesan Agemaki and her Gallant Sukeroku

Pillar-print, 62.5 x 13 cm. c.1797-8

These two lovers figure prominently in another of the *joruri* referred to in the note to Plate 31. Sukeroku was one of the *Otokodate*, a league of men banded together to help the weak against their oppressors. He rescues Agemaki, a courtesan, and she falls in love with him.

UTAGAWA TOYOHIRO

Youth and Girl in a Pleasure-Boat

Pillar-print, 68.9 x 12.1 cm. c.1793-4. Tokyo, Private Collection

Because Utagawa Toyohiro (1763-1828) was eclipsed during his life by Toyokuni, his fellow pupil under Toyoharu, and because he was also remembered by later generations as the master of Hiroshige, his own not inconsiderable contribution to the colour-print is apt to be disregarded. His book illustrations are of high quality; in such prints as the 'Six Jewel Rivers' he shows a mastery in handling the landscape background that does much to explain his inspiration to Hiroshige; and in his pillar-prints, often of surprising originality in design, he made a genuinely important contribution to the Ukiyo-e print.

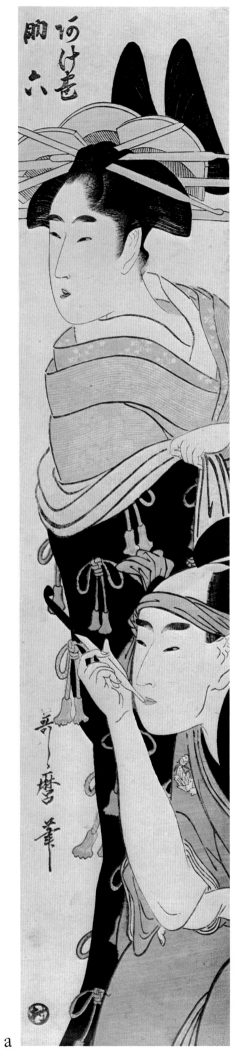

a

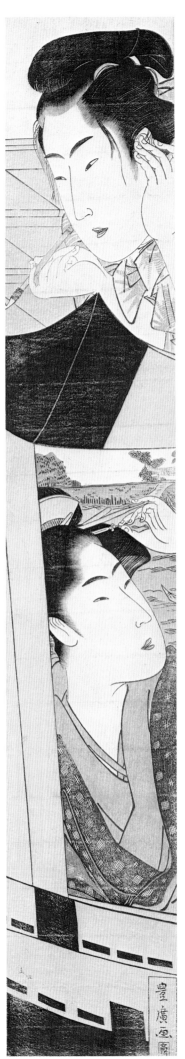

b

TOSHUSAI SHARAKU

The Actor Segawa Tomisaburo as Yadorigi in a Play Performed in 1794

36.2 x 23.8 cm. London, British Museum

The prints of Toshukai Sharaku relate to plays performed from the fifth month of 1794 to the first month of 1795. Nobody is satisfied with the almost entire lack of information about him, and many theories have been propounded to fill the vacuum. Certainly, the appearance of this dynamic artist in the Ukiyo-e ranks is one of the mysteries of Japanese art. Without, so far as has been traced, previous training, he designed in 1794-5 a series of about 150 actor-prints, all under the imprint of Tsutayo Jusaburo. Whatever they may owe to the example of Shunsho, Shunei, the Osaka artist Ryukosai, or even, possibly, Toyokuni, they are among the most powerfully original of all Japanese prints. The 'large head', in particular, seems to have been introduced by Shunei and Shunko, but Sharaku's intensity of characterization and the effect of bizarre colour against the dark mica backgrounds are without parallel in Ukiyo-e.

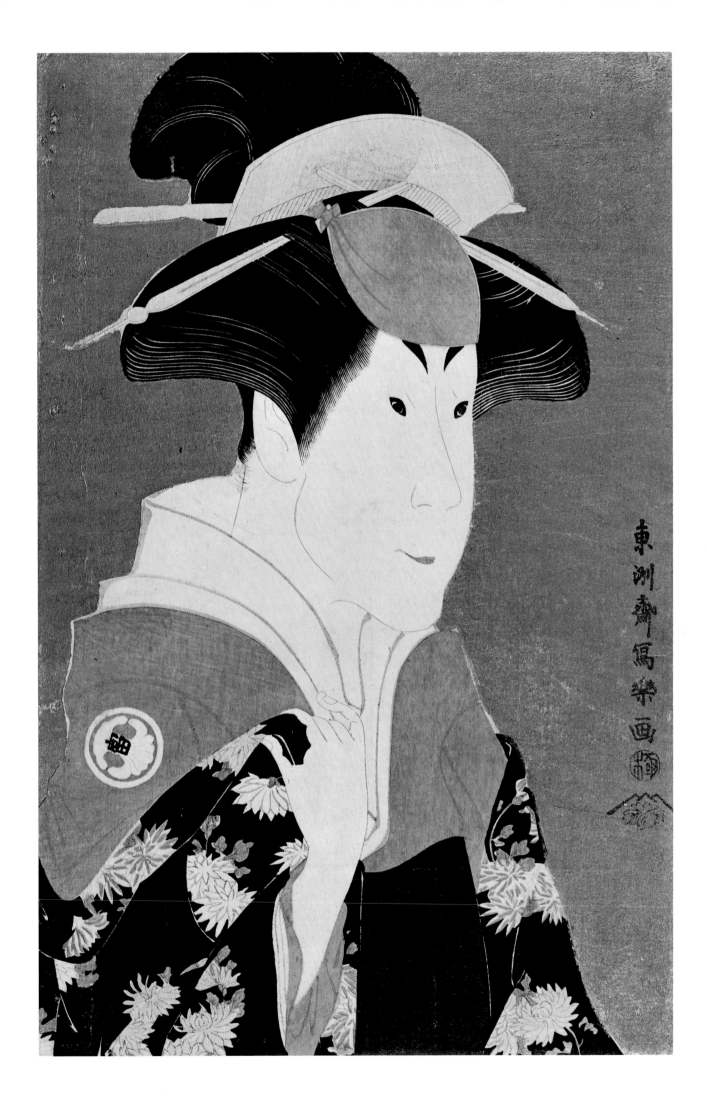

The Actors Nakamura Konozo and Nakajima Wadaemon in Character

Mica-ground. 37.1 x 22.9 cm. 1794. London, British Museum

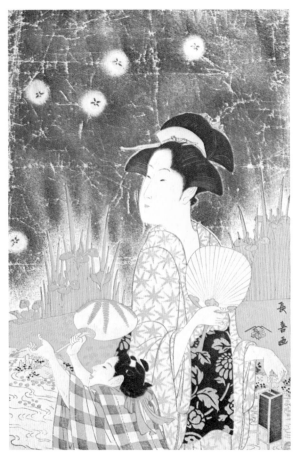

Sharaku designed only five double bust portraits, all are rare and considered among his chief masterpieces. The two actors are in a scene from a play called 'A Medley of Tales of Revenge', performed in the Fifth Month of 1794. The unpleasant character at the right, played by Wadaemon, has the nickname 'Dried Codfish' and he is roundly cursing the impassive 'Homeless Boatman', played by Konozo. At one time, the print had the imaginative title 'A wrestler being cursed by his manager', and it is a pity that recent findings as to the correct roles of the actors has ruled out its use.

Kabukido Enkyo (worked 1796/7) designed portrait heads in imitation of Sharaku. Eishosai Choki worked from the 1770s to c.1800. A fellow student with Utamaro under Sekien, at which time he bore the name Shiko, Choki was influenced by Utamaro and Kiyonaga and was one of the first to pay Sharaku the tribute of imitation. But the essential Choki is confined to a handful of lovely prints, dated about the middle of the nineties, often with mica-grounds, which have what has been described as 'an emotional quality rare in Ukiyo-e' (Fig. 29). He seems to have had an inspired and short-lived period of great originality, like Cotman or Samuel Palmer. About 1798, the name Shiko again appears on prints, but though some have held that they too were the work of Choki, stylistically it is difficult to believe that they are not the work of a different master.

Fig. 29
Eishosai Choki:
'Firefly Catching'

c.1794-5. London, British
Museum

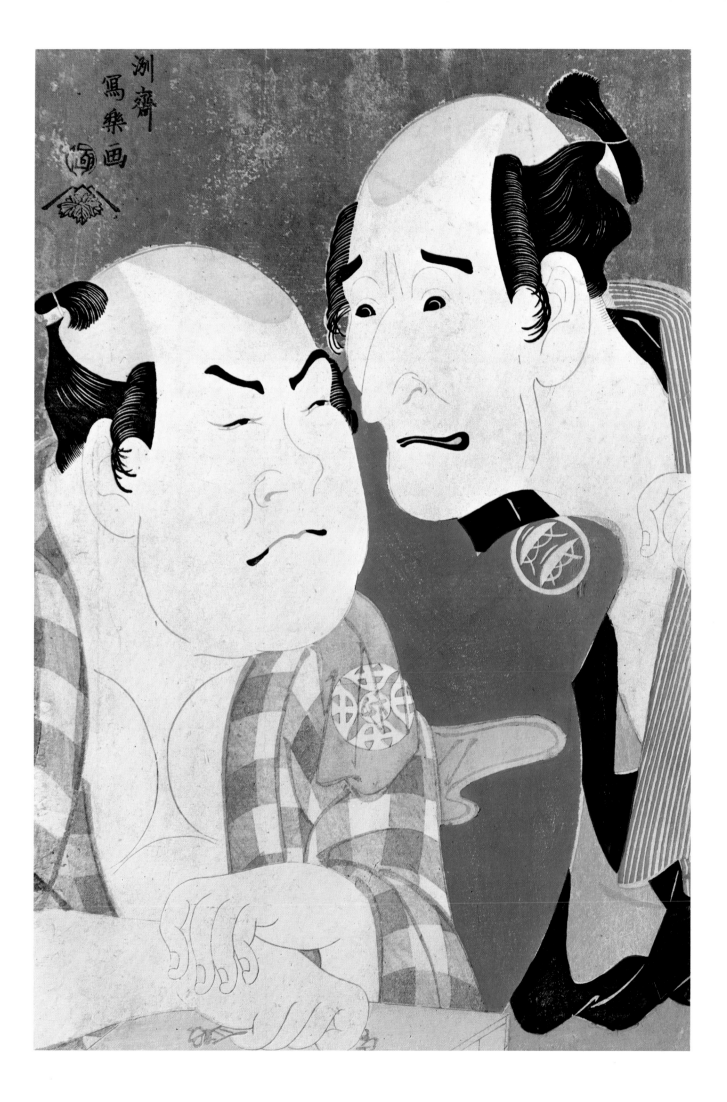

CHOBUNSAI EISHI

The Courtesan Itsutomi Holding a Plectrum

Mica-ground. 38.1 x 25.4 cm. c.1794. London, Victoria and Albert Museum

Fig. 30
**Chobunsai Eishi:
'Evening under
the Murmuring
Pines'**

A triptych, one of a series
'Genji in Modern Dress'.
Each sheet 35.6 x 25.4 cm.
c.1792. London, British
Museum

One of the few Ukiyo-e artists that could claim gentle descent, Chobunsai Eishi (1756-1829) forsook the Kano school and took Kiyonaga as a model. He found the tall forms affected by Kiyonaga at one period particularly engaging and, like Utamaro, wilfully exaggerated the height and slimness of his courtesan models and produced designs of a rare elegance. His triptychs of 'Genji in Modern Dress' (Fig. 30) are among his greatest triumphs. After 1800 he gave himself up entirely to painting, in which sphere he is considered one of the most accomplished of the school.

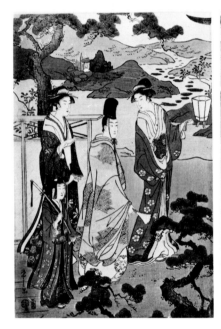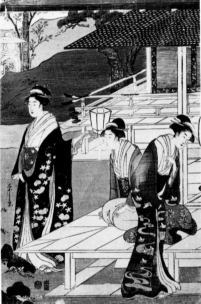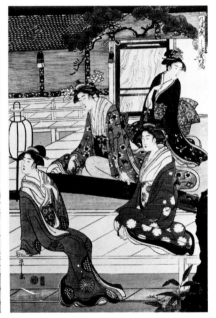

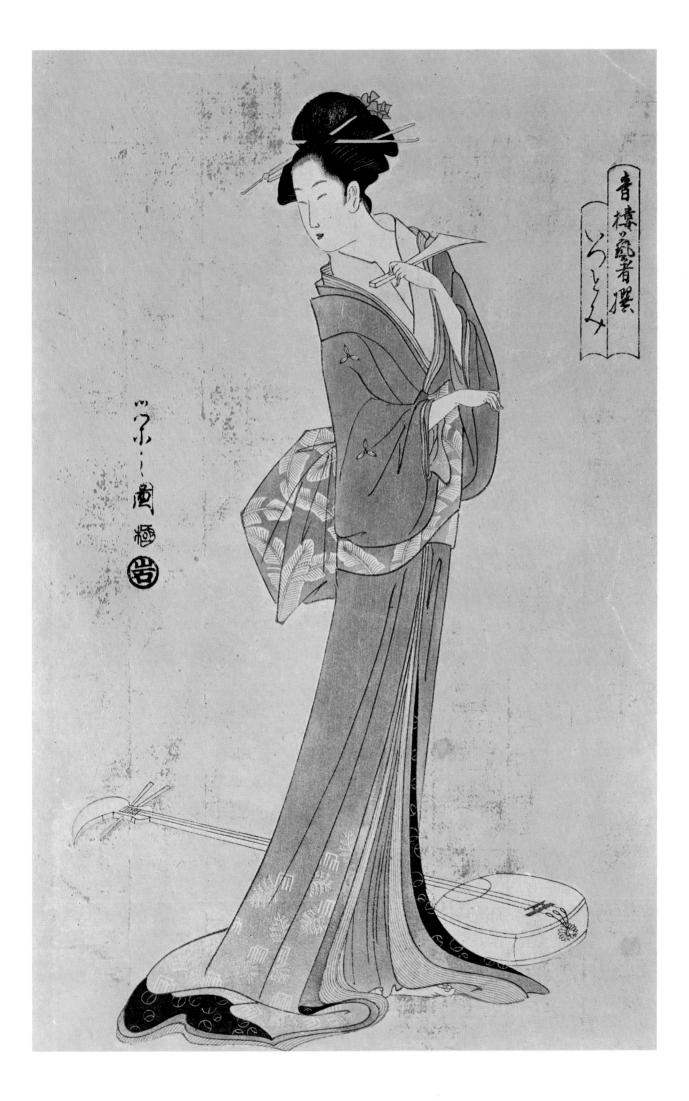

Head of a Girl in a Transparent Hood

24.1 x 36.8 cm. c.1795-6. San Francisco, Grabhorn Collection

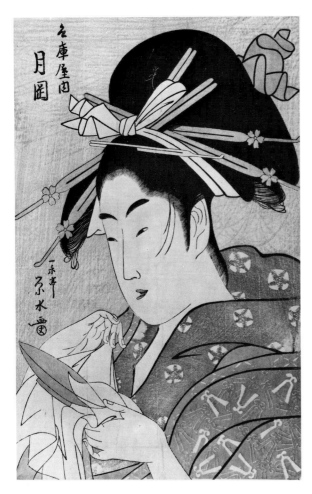

Fig. 31
Ichirakutei Eisui:
The Courtesan
Tsukioka
Unwrapping a
Sake-Cup

38.1 x 25.4 cm. Private
Collection

As is the case with so many Ukiyo-e artists, practically no biographical details exist concerning Chokosai Eisho (active 1785-1800). Though his somewhat simpering beauties are usually recognizable, he followed his master Eishi closely in style and choice of subject, eschewing the stage, concentrating on the courtesan's world, and designing some 'large heads' which, for all that they may owe to Utamaro, are among the most memorable prints of the mid-nineties.

Ichirakutei Eisui worked at the same time and in rather the same manner as Eisho, but his large heads in particular are subtly distinguishable from other contemporaries' work (Fig. 31).

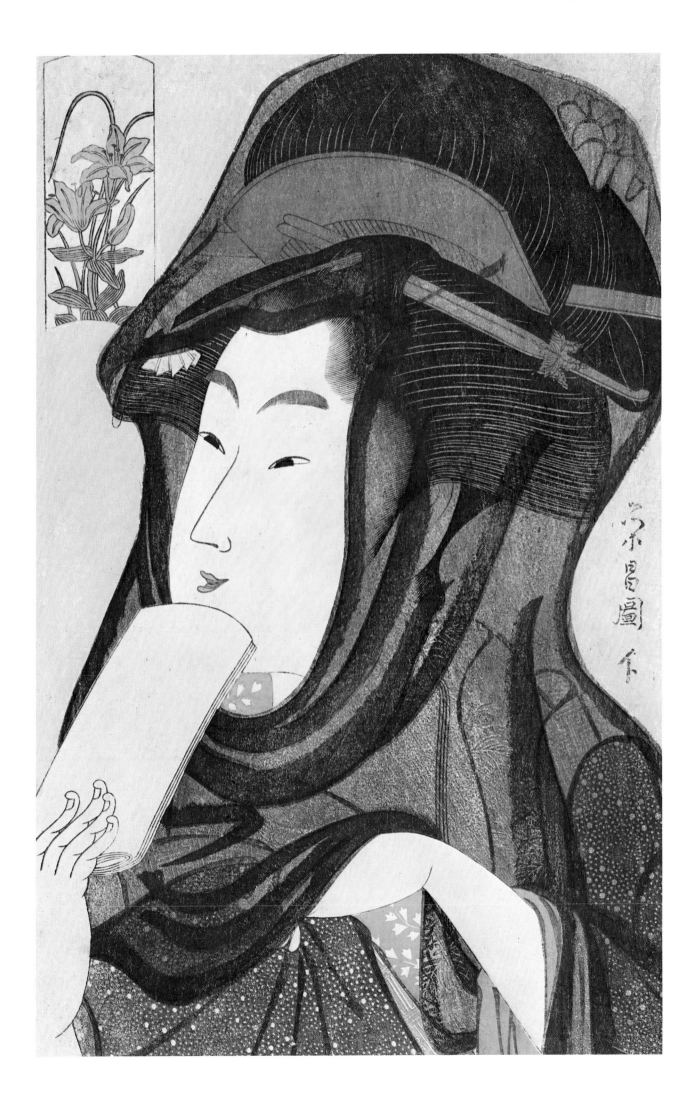

Otatsu of the Ryogoku District of Edo

One of a set of three. 37.5 x 26 cm. c.1795. Paris, Musée Guimet

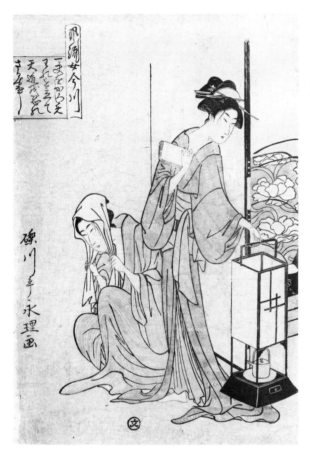

Fig. 32
**Rekisentei Eiri: A
Man Preparing to
Depart from a
Courtesan**

One of a set 'Up-to-date
Onna Imagawa'. 34.3 x
22.9 cm. Brussels, Musées
Royaux d'Art et d'Histoire

Although Eiri (active c.1789-1800) was patently a follower of Eishi, his few and rare prints have a marked individuality. The set of three, of which Plate 37 is one, are of an unsurpassable elegance. The few fine 'large heads' on mica-ground make it surprising that his oeuvre should be so small: he was capable of matching the best of his contemporaries. Some identify Rekisentei Eiri with this artist, but the names are written with different characters and there are apparently irreconcilable differences in style (Fig. 32).

Plate 37 is one of a set of three prints relating, surprisingly, to low-class prostitutes of the Three Cities (Kyoto, Edo and Osaka). Fig. 32 is one of a set based, irreligiously, on a classic.

Tamagawa Shucho (active 1795-1800) designed prints in a manner that partakes of something of the styles of Eishi, Utamaro and Choki.

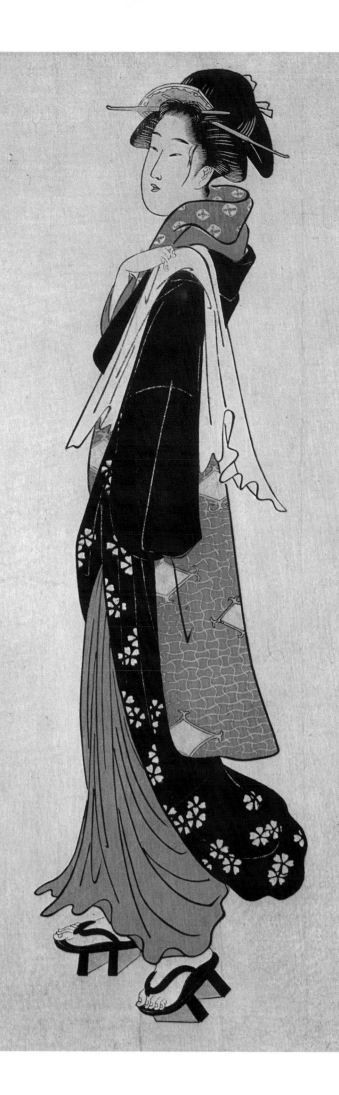

The Actor Iwai Hanshiro in a Feminine Role, in a Play Performed in 1795

From the series 'Actors as they appear on the Stage'. 38.1 x 25.4 cm.
Hawaii, Honolulu Academy of Arts, C. Montague Cooke Jr. Memorial Collection

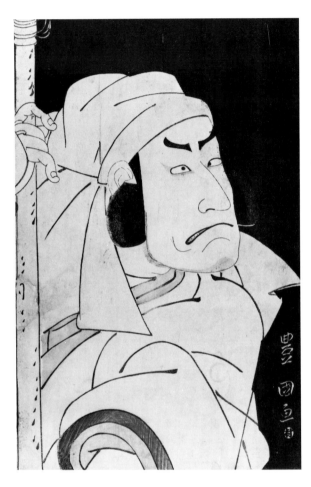

Utagawa Toyokuni (1769-1825) was a pupil of Toyoharu, and became the outstanding master of the Utagawa line. Influenced by Shunsho, Eishi, Utamaro and Sharaku, he was an eclectic whose versions of those artists are always a little coarser than the originals (Fig. 33). His most typical work is in the realm of the actor-print, of which he was the undisputed master after Shunsho and Sharaku had left the field. In his series 'Actors as they appear on the stage' he reaches heights which give him a claim to be among the greatest of Ukiyo-e, but he came at an unpropitious time when standards of life and art were falling, and after the turn of the century his style went rapidly downhill. His output was enormous, and his school composed a large number of artists, much of whose work belongs to the nineteenth century and exemplifies the debased standards of the period.

Fig. 33
Utagawa
Toyokuni: Actor,
possibly Arashi
Ryuzo, as a
Travelling Priest

35.8 x 24.5 cm. Private
Collection

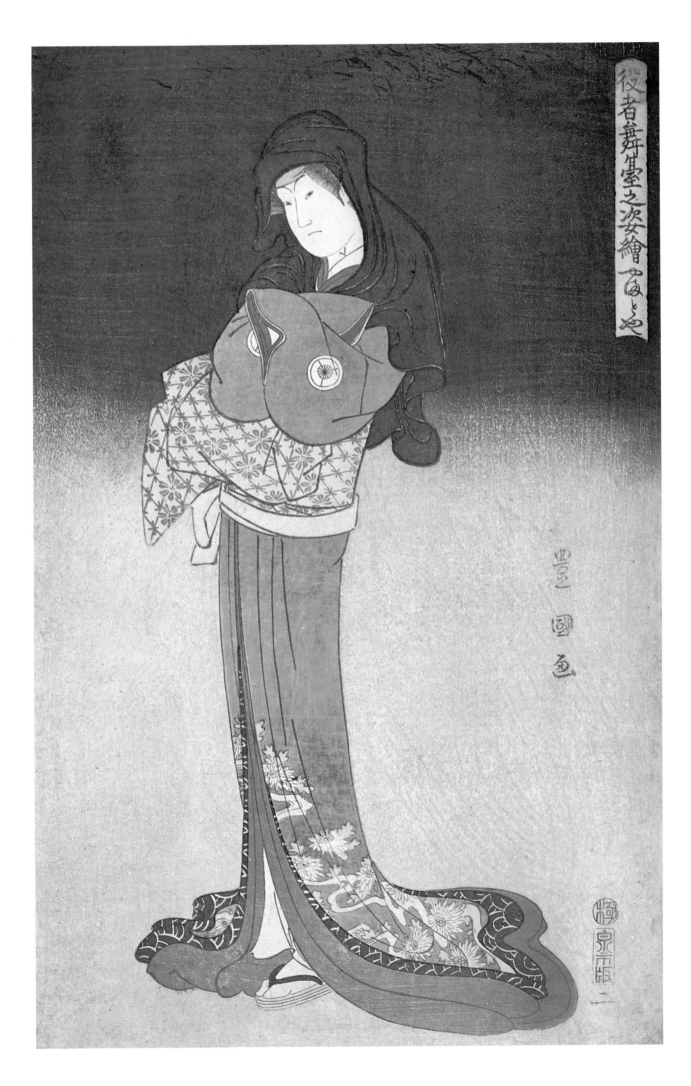

The Actor Ichikawa Ebizo in the Shibaraku Episode in a Play Performed in 1796

38.7 x 25.7 cm. London, British Museum

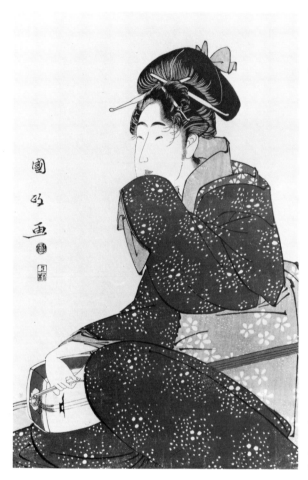

Utagawa Kunimasa (active 1795-1810) was one of Toyokuni's first pupils, and had a relatively small output. He was much influenced by Sharaku, and his own 'large heads' are of great merit (Plate 39). His few prints of *geisha* also have a rare distinction (Fig. 34).

Fig. 34
Utagawa
Kunimasa: *Geisha*
Kneeling with a
Samisen on her Lap

37.5 x 25.4 cm. Private
Collection

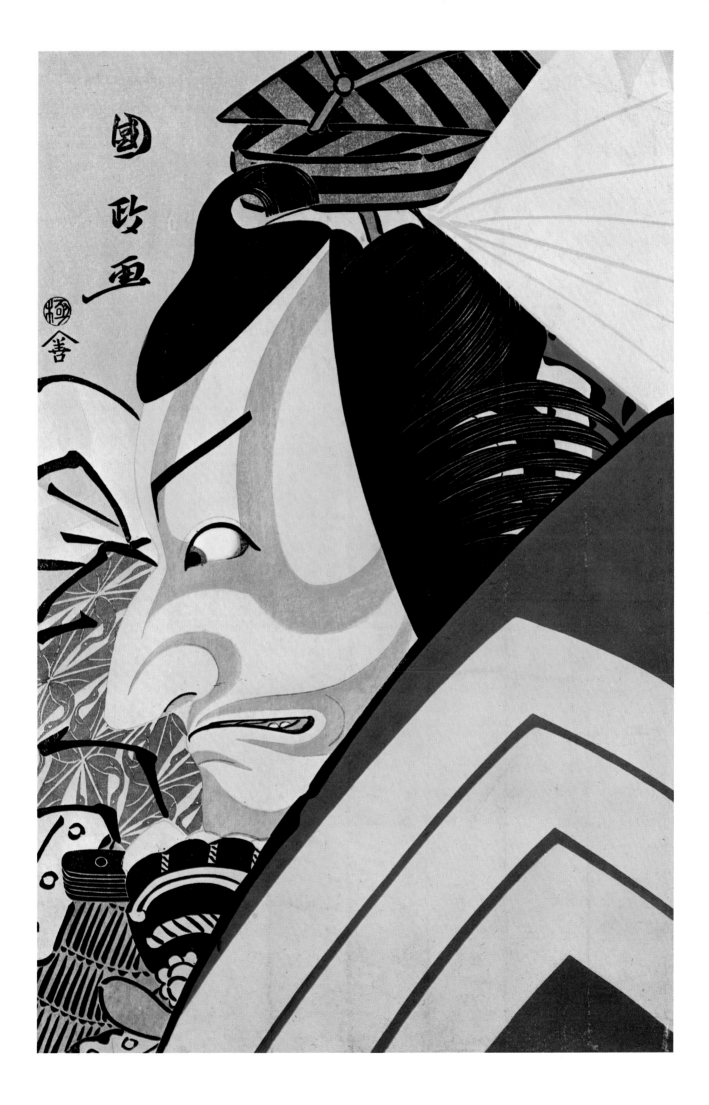

The Wrestler Tanikaze and his Pupil Taki-no-oto

37.8 x 25.1 cm. c.1796. London, British Museum

Katsukawa Shunei (1768-1819) was another pupil of Shunsho's with more marked individuality than Shunko. His actor prints show affinities with Shunsho's but even in these his originality comes out in a predeliction for strong, macabre designs and sombre colour schemes. Like Shunko, he was among the first to draw large portrait heads of the kind Sharaku and Utamaro made their own (Fig. 35), and he also excelled in prints of wrestlers, who were fêted by the Edo crowds as the professional boxer is among us. Altogether, Shunei is one of the most talented artists of the late eighteenth century. Shunei's pupils include Shunteí and Kashosai Shunsen.

Fig. 35
Katsukawa Shunei:
An Unidentified
Actor, Half-Length

37.5 x 24.4 cm. c.1796.
Private Collection

The Actor Nakayama Tomisaburo as the Courtesan O'karu in a Play Performed in 1795

38.4 x 25.7 cm. Hawaii, Honolulu Academy of Arts, Michener Collection

Fig. 36
Katsukawa
Shunen: Portrait in
a Mirror of the
Actor Otani Oniji
III in a Play
Performed in 1794

Fan print. The Hague,
Heinz M. Kaempfer
Collection

Actors playing the part of women, known as *onnagata,* were astonishingly convincing in their portrayal of femininity, and the graceful pose of this particular character demonstrates Shunei's great skill.

Other pupils of Shunsho include Shundo, Shunen, Shunjo, Shunyoku, Shunrin, Shunsen, and Shunkyo. Most of them produced competent actor-prints, generally in the *hosoban* format, but Shunen is best known by some exceptional fan prints portraying the heads of actors reflected in mirrors (Fig. 36).

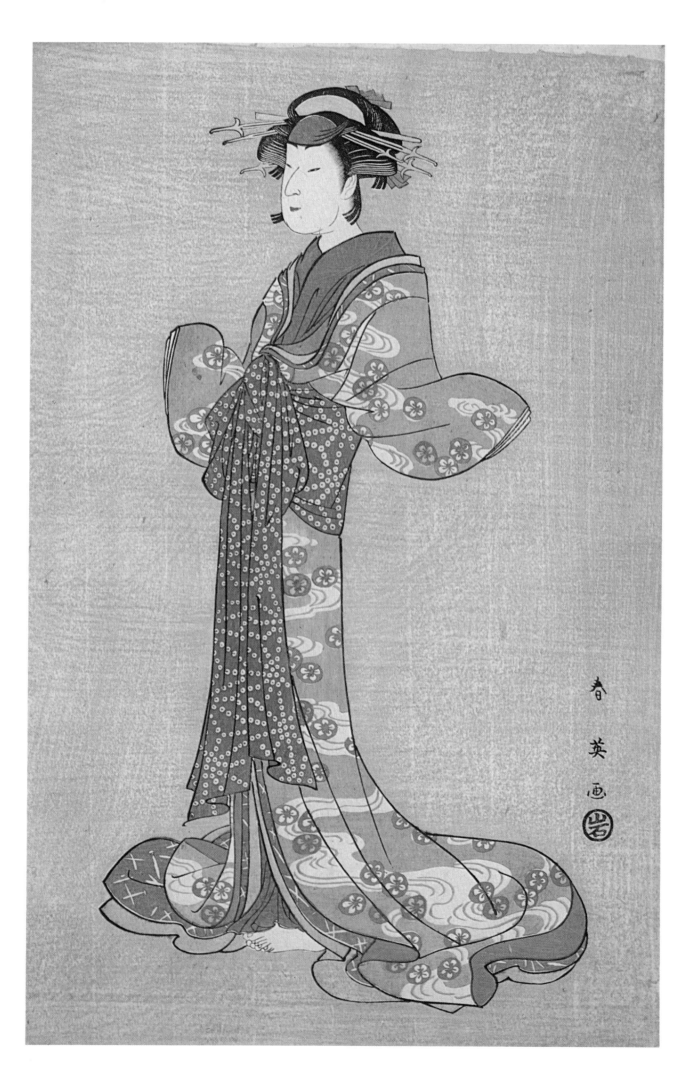

Cuckoo and Azalea

From the series known as the 'Small Flowers'. 25.4 x 18.4 cm. c. 1828.
London, British Museum

Fig. 37
Katsushika
Hokusai: The
Lover in
the Snow

Surimono. 12.1 x 15.9 cm.
London, British Museum

Edo-born, the son of a mirror-maker, Katsushika Hokusai (1760-1849) was apprenticed to a wood-block-cutter, but soon turned to designing. His first master was Shunsho, under whom he took the name Shunro. His first illustrated book appeared in 1780, the forerunner of an enormous output in this field. His work covers almost every other sphere of Ukiyo-e activity, actor-prints in the Shunsho manner, Uki-e ('perspective') views, *bijin-ga*, first with a Kiyonaga cast and then with something nearer to the Utamaro model, *surimono* of unsurpassed delicacy and invention (Fig. 37) and bird and flower-prints (Plate 42); but his finest work is pre-eminently in landscape, especially the great series that appeared after 1820 – the 'Thirty-six Views of Fuji' (Plate 43), the 'Waterfalls' (Plate 44), the 'Bridges' and others.

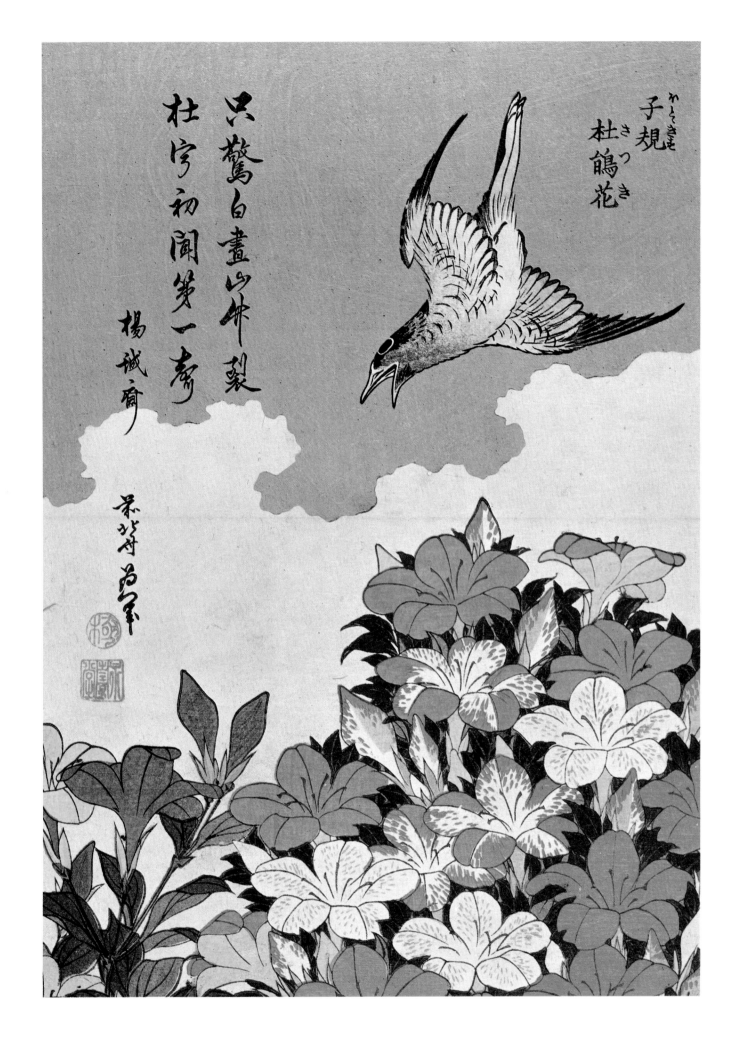

KATSUSHIKA HOKUSAI

Fuji in Clear Weather

From the series 'The Thirty-six Views of Fuji'. 26.4 x 38.4 cm. c.1823-9.
London, British Museum

Mount Fuji was an obsession of the Japanese people, an ever-recurrent theme in poetry and art. Hokusai depicts the volcanic cone, slightly assymetrical as if lending itself to a strongly national trend in composition, in many paintings and prints, but makes it the central theme in two major series, one in broadsheet form, the 'Thirty-six Views of Fuji' (extended, without amendment to the title, to forty-six) and the other as a book in three volumes, the 'One hundred Views of Fuji', volumes one and two published in 1834/5, and volume three in 1839 (Fig. 38)

Fig. 38
Katsushika
Hokusai: Fuji from
Sode-ga-ura

From the 'One hundred
Views of Fuji'. Vol. I.
Private Collection

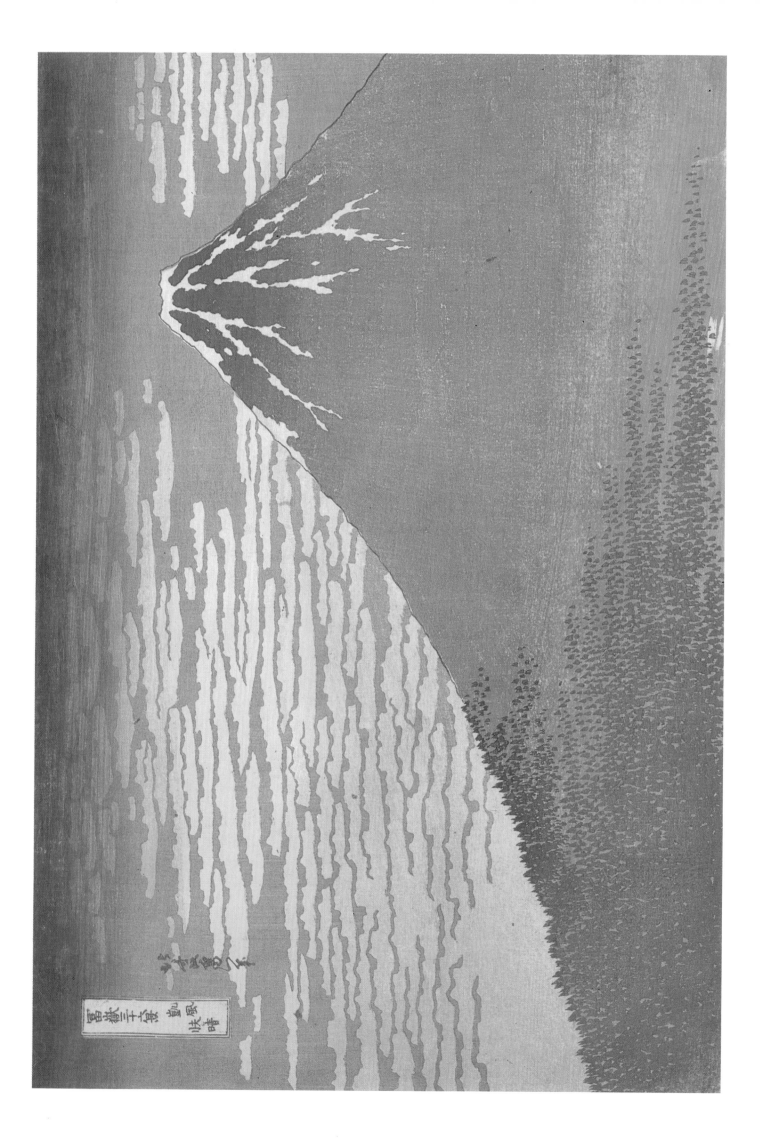

The Waterfall of Yoshino

From the series 'Going round the Waterfalls of the Country'. 38.1 x 25.4 cm. c.1830

In the 1830s both Hokusai and Hiroshige were catering for the thirst of the Japanese people for views of their own country, forbidden as they were to travel outside Japan, and travel within the country itself far from easy or encouraged. Hokusai made views of Fuji from every conceivable aspect, pictures of famous bridges, and a notable series of prints of waterfalls, from which Plate 44 is taken. The waterfall series is characterized by some of Hokusai's most daring improvisations on landscape themes, and in the Yoshino print he creates a colourful fantasy, far removed from strict topography, with an allusion to a legend that the warrior hero Yoshisune once washed his charger below the fall.

Hokusai had a large number of pupils, of whom the following are the most important: Shinsai, Hokkei, Hokuju, Yanagawa Shigenobu, Isai, Gakutei, Taito II, Hokuba and Hokui. Minor pupils were: Bokusen, Hokuun, Hokutei, Hokusui and Hokui. None of them approached Hokusai's mastery in landscape, though several excelled as designers of *surimono* (Fig. 39), and Hokuba as a painter.

Fig. 39
Aoigaoka Hokkei:
Mandarin Ducks

From a series of thirty-six birds. Surimono, with Kyoka above the design. 21.3 x 18.1 cm. Private Collection

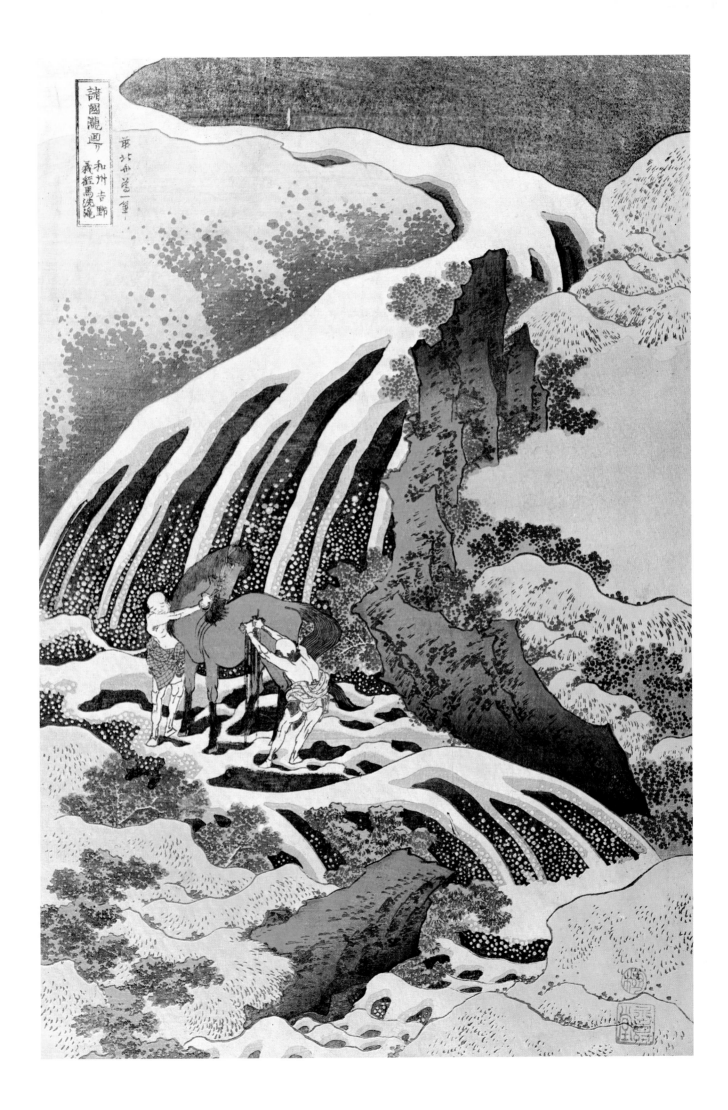

Moonlight, Nagakubo

One of the 'Sixty-nine stations of Kisakaido'. 21.9 x 34.6 cm. c.1840.
London, British Museum

Fig. 40
Ando Hiroshige:
Irises, Illustrating
Summer

In a set of 'Flowers of the
Four Seasons'. Fan-print.
Private Collection

Providentially, as we now see it, Ando Hiroshige (1797-1858) failed to gain admittance to Toyokuni's academy and studied under Toyohiro instead. His early work, book-illustrations and figure designs, is not remarkable, but about 1826 his genius for landscape was made evident in a series of Edo views, and confirmed beyond doubt in 1834 by his first series of prints of the 'Fifty-three Stations of the Tokaido', the great highway between the new and old capitals, Edo and Kyoto. From that time on, Hiroshige's industry in recording the beautiful Japanese scenery was astonishing, literally thousands of designs pouring from his brush. Among the most famous of the other series are 'Eight Views of Lake Omi'; the 'Sixty-nine Stations of the Kisakaido'; 'Views of the Sixty-nine-odd Provinces'; the 'One hundred Views of Edo' (Fig. 8); and the 'Thirty-six Views of Fuji'. His *kacho-e* and designs for fan-mounts are also noteworthy (Fig. 40).

Fig. 40 has an inset figure of the poet Narihara.

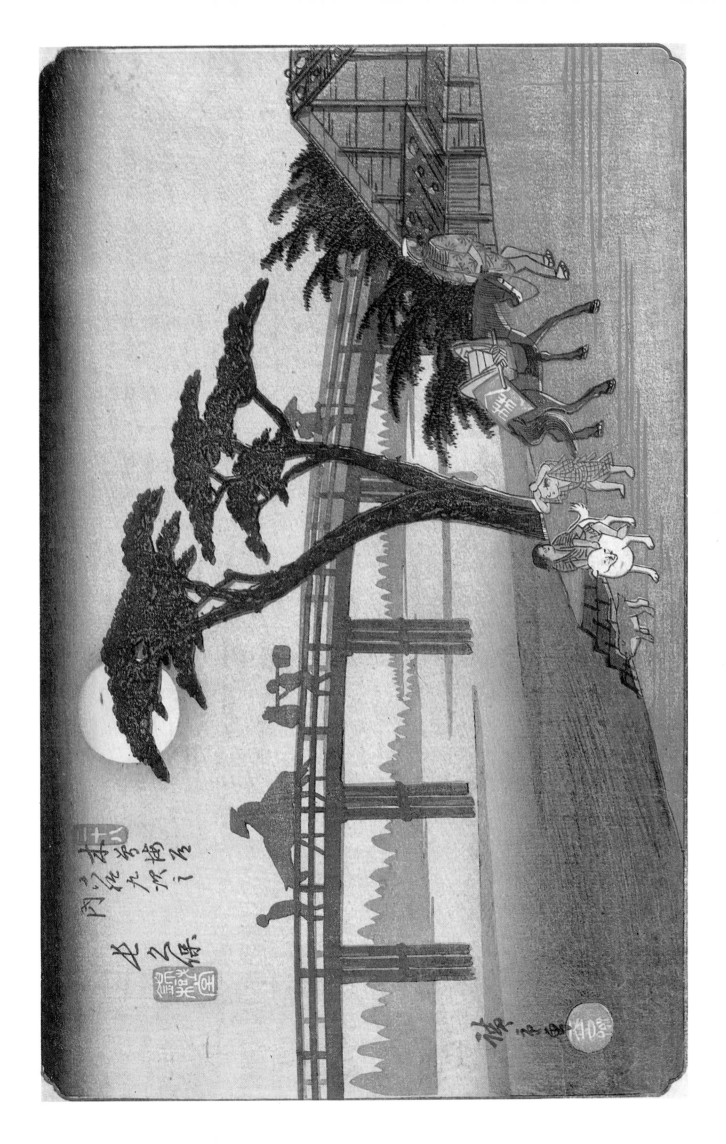

The Bow Moon

One of an uncompleted set. 37.8 x 16.2 cm. c.1830-5. Private Collection

With the limited means of the colour print, Hiroshige contrived some of the most romantic and atmospheric of all moonlight scenes, and each major series has a few such prints that have always had a special place in the affection of collectors in the West. It has always been a cause of disappointment that, for unknown reasons, Hiroshige designed only two prints of a series that was entitled 'Twenty-eight Views of the Moon' and presumably was intended to show the moon in all its phases, in all kinds of location. One print shows a full moon seen through maple leaves beyond a waterfall; the other, Plate 46, is surely one of the most imaginative landscapes created by any artist, East or West.

Originally a pupil of the Kano school Keisai Eisen (1790-1848) went over to the Ukiyo-e style. His pictures of beauties suffer from the falling standards of his time, but his landscapes often rival those of Hiroshige, with whom he collaborated in the series 'Sixty-nine Stations of the Kisakaido' (Fig. 41), the inland highway between Edo and Kyoto. Teisai Sencho (worked 1830-50) was a pupil of Eisen and designed *bijin-ga* in his manner.

Sugakudo (worked mid-nineteenth century) designed *kacho-e* and is principally known by his set of 'Forty-eight Birds drawn from life' (1859).

Kyosai (1831-89) was an artist who carried something of the Ukiyo-e manner and gusto into the latter half of the nineteenth century. His drawing is vigorous and often humorous or grotesque.

Fig. 41
Keisai Eisen: Itabana

One of the 'Sixty-nine Stations of the Kisakaido'. 1835-9. 25.4 x 38.1 cm. Private Collection

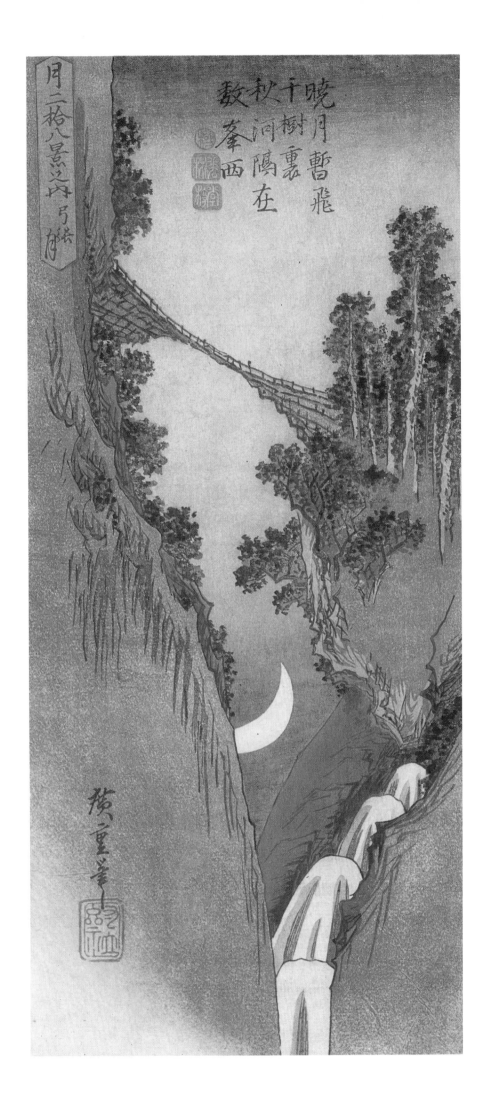

Tameijiro dan Shogo, One of the 108 Heroes of the Suikoden, Grappling with an Adversary under Water

38.1 x 26.4 cm. 1827-30. London, B.W. Robinson Collection

Fig. 42
Sadahide: Dutch
People on Holiday
in Yokohama

One sheet of a triptych,
dated 1861.
38.1 x 25.4 cm.
Brussels, Musées Royaux
d'Art et d'Histoire

Utagawa Kuniyoshi (1797-1861), again, shows an astonishing fecundity, and occasionally his prints, like those from the series illustrating scenes from the life of Nichiren, founder of a Buddhist sect, reach great heights. His illustrations to the heroic periods of Japanese history have great invention and gusto, and his landscapes have qualities which put them among the most admired of nineteenth century prints. Other notable series show a curious adaptation of Western idioms.

Pupils and followers of Toyokuni, Kunisada or Kuniyoshi who worked in the last decades of the print are very numerous. Those most likely to be encountered are Kuninaga, Kunimitsu, Kunitsuna, Kunikazu, Kunihisa, Kunimori, Kunitomi, Kuniharu, Kunitane, Kuniteru, Kuninao, Kuniaki, Kunichika, Kunihiko, Yoshitaki, Yoshiharu, Yoshikazu, Yoshitora, Yoshimaru, Yoshitoshi, Sadakage, Sadafusa, Sadanobu, Sadahide (Fig. 42), Sadahiro, Fusatane, Tominobu and Toyohida.

Fig. 42 is typical of the large number of prints of foreigners issued after the opening of the port (*Yokohama-e*).

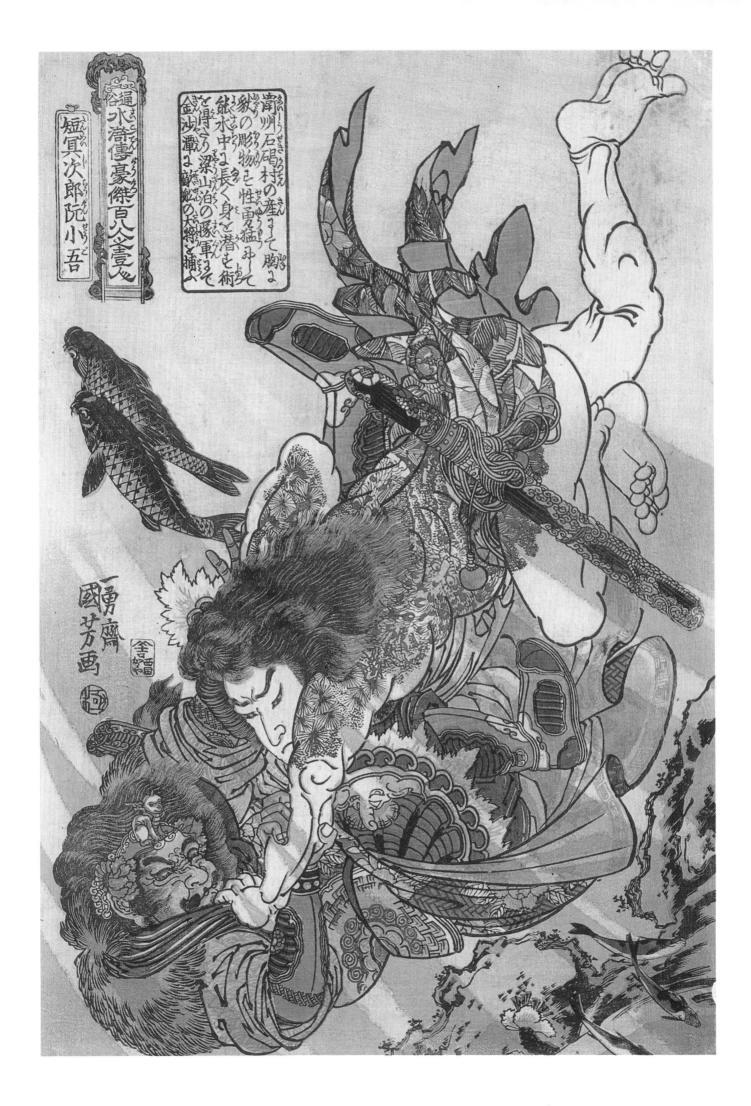

The Actor Ichikawa Danjuro VII in Character

Mica-ground. 38.1 x 25.7 cm. c.1820. Private Collection

Utagawa Kunisada (1786-1864) was another pupil of Toyokuni, whose name he adopted in 1844 (the third to bear the name, Toyoshige, an earlier pupil, having succeeded to it when Toyokuni died in 1825). Kunisada's career tells the tragedy of the downfall of Ukiyo-e. With evident talent and tremendous verve, his early prints have qualities that link him with the great days of the school, but the great mass of his prints are hastily designed, over-coloured and badly printed. His few landscapes, however, have unusual distinction (Fig. 43).

Plate 48 comes from a *Kyogen* set of half-length figures that contain some of the artist's finest actor-prints.

In the first half of the nineteenth century colour-prints were produced at Osaka as well as in Edo, and a local school of designers was established, influenced by both Hokusai and Kunisada, who are known to have spent some time in the town. The prints suffer from some of the defects of the Edo prints of the time, being frequently ill-designed and crudely coloured, but they have at least the merit of being, as a rule, well printed. Some pupils of Kunisada are mentioned in the note to Plate 47. Hokushu, Hokuei and Hirosada occasionally produced some splendid designs; other less-inspired artists are Hokusen, Shigeharu, Ashihiro, Ashiyuki, Ashimaro, Ashikiyo and Ashikuni. Matsukawa Hanzan, also of Osaka, was a *surimono* designer of some ability.

Fig. 43
Utagawa Kunisada:
Sunrise over the
'Husband and
Wife' Rocks at Ise

1830s. 24.8 x 37.5 cm.
Private Collection

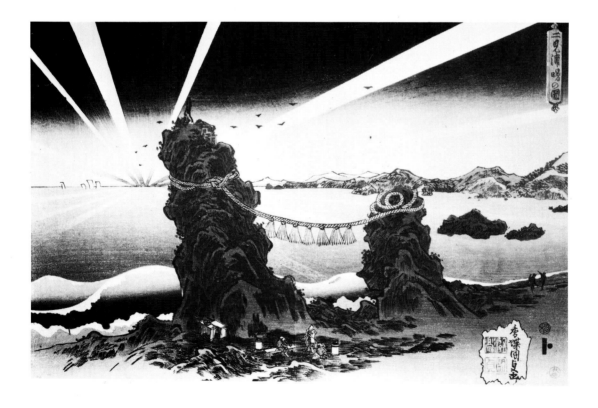

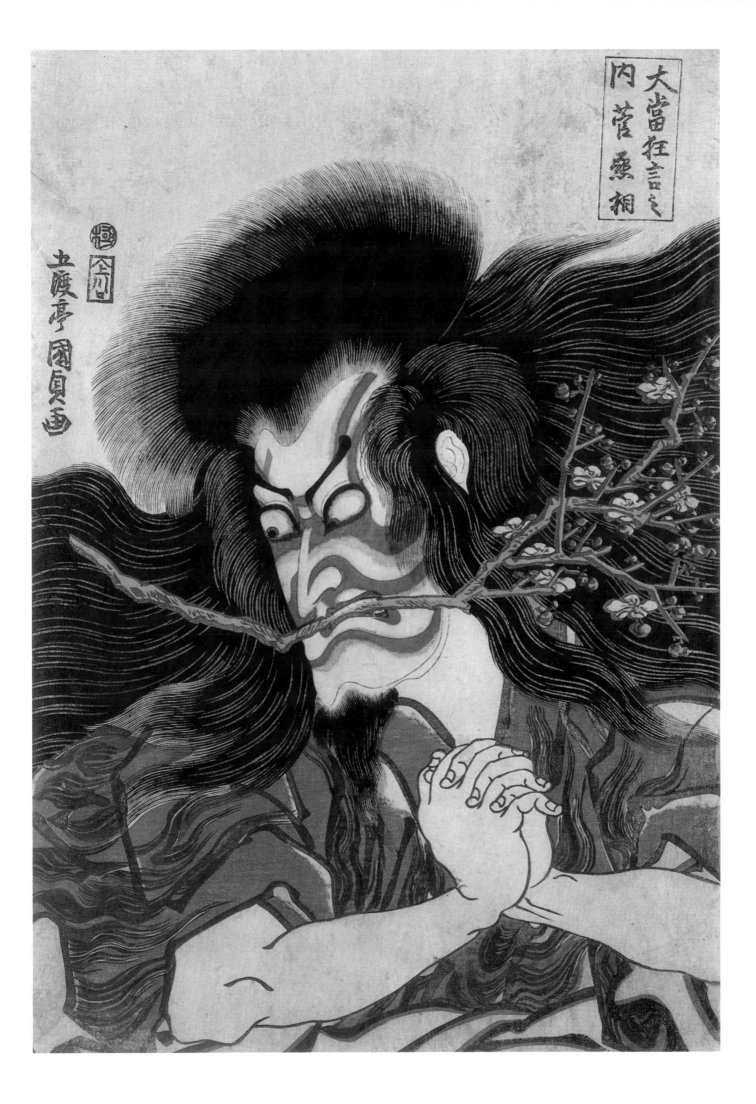

PHAIDON COLOUR LIBRARY
Titles in the series

| FRA ANGELICO | BONNARD | BRUEGEL | CANALETTO | CARAVAGGIO | CEZANNE | CHAGALL | CHARDIN | CONSTABLE |
| Christopher Lloyd | Julian Bell | Keith Roberts | Christopher Baker | Timothy Wilson-Smith | Catherine Dean | Gill Polonsky | Gabriel Naughton | John Sunderland |

| CUBISM | DALÍ | DEGAS | DÜRER | DUTCH PAINTING | ERNST | GAINSBOROUGH | GAUGUIN | GOYA |
| Philip Cooper | Christopher Masters | Keith Roberts | Martin Bailey | Christopher Brown | Ian Turpin | Nicola Kalinsky | Alan Bowness | Enriqueta Harris |

| HOLBEIN | IMPRESSIONISM | ITALIAN RENAISSANCE PAINTING | JAPANESE COLOUR PRINTS | KLEE | KLIMT | MAGRITTE | MANET | MATISSE |
| Helen Langdon | Mark Powell-Jones | Sara Elliott | J. Hillier | Douglas Hall | Catherine Dean | Richard Calvocoressi | John Richardson | Nicholas Watkins |

| MODIGLIANI | MONET | MUNCH | PICASSO | PISSARRO | POP ART | THE PRE-RAPHAELITES | REMBRANDT | RENOIR |
| Douglas Hall | John House | John Boulton Smith | Roland Penrose | Christopher Lloyd | Jamie James | Andrea Rose | Michael Kitson | William Gaunt |

| ROSSETTI | SCHIELE | SISLEY | SURREALIST PAINTING | TOULOUSE-LAUTREC | TURNER | VAN GOGH | VERMEER | WHISTLER |
| David Rodgers | Christopher Short | Richard Shone | Simon Wilson | Edward Lucie-Smith | William Gaunt | Wilhelm Uhde | Martin Bailey | Frances Spalding |